IMAGES
of America

AFRICAN-AMERICAN LIFE IN
DEKALB
COUNTY
1823–1970

IMAGES
of America

AFRICAN-AMERICAN LIFE IN
DeKALB
COUNTY
1823–1970

Herman "Skip" Mason Jr.

ARCADIA

Published by Arcadia Publishing,
an imprint of Tempus Publishing, Inc.
2 Cumberland Street
Charleston, SC 29401

Printed in Great Britain.

Library of Congress Catalog Card Number: 98-88063

For all general information contact Arcadia Publishing at:
Telephone 843-853-2070
Fax 843-853-0044
E-Mail arcadia@charleston.net

For customer service and orders:
Toll-Free 1-888-313-BOOK

Visit us on the internet at http://www.arcadiaimages.com

Dedication

To Mama, "Pop," Arthur, Dionne and Minyon, Hosea Williams (for reminding me that I am "unbossed" and unbought), Earl and Carolyn Glenn for sharing Arcadia Publishing with me and for championing the cause of African-American life in DeKalb County, Paul Robinson, the staff and board of the DeKalb Convention and Visitors Bureau for your foresight in commissioning the initial research of DeKalb County and your passion for having this history preserved, the 100 Black Men of DeKalb County for your commitment to uplifting our African-American males (thank you for allowing me to share my love of history with our boys), Narvie Jordan Harris (an American treasure), and also a thank you to Jane Dejournette.

To three beloved high school teachers—Anita Jenkins Greene (who introduced me to African-American history in an unusual manner), Jacquelyne Welch Burke (my high school English teacher and former Decatur resident), and LaDaisy S. King (from whose lessons taught to me 20 years ago have influenced my love for writing and creativity)—and finally, to Dr. William Flippen, Bishop Othal Lakey, Rev. Stephen Delaine, and the Westside C.M.E. Church family for your spiritual guidance and support, and for reminding me that "If you seek first the kingdom of God and his righteousness, all things will be added to you."

As always this book is for the nieces and nephews—Shakari, Jolaun, Kenyondra, and Bodford, Arthur Conley, and Michael Goodman.

INTRODUCTION

Stony the road we trod, bitter the chastening rod. Felt in the days when hope unborn had died. Yet with a steady beat, have not our weary feet. Come to the place for which our fathers died. We have come treading our path through the blood of the slaughtered. We have come over a way that with tears have been water. Out from the gloomy past, Till now we stand at last. Where the white gleam of our bright star is cast.

—James Weldon Johnson, *Lift E'vry Voice and Sing*

I am honored to present this visual compilation of DeKalb's African-American history in observance of the county's 175th anniversary celebration in 1998. No observance of any county would be complete without reflecting on its African-American history. More importantly, this is a history of Decatur and DeKalb County that most of its current residents have little knowledge of. At the palatial home of Larry and Barbara Epps, two of Lithonia's and DeKalb County's most community-oriented citizens, I have met many local residents and have wondered if these "new-found" DeKalbites recognize just how rich a history the county has. Has it ever occurred to them that the growth of DeKalb County today is due to the sacrifices and gains made decades ago by African-American pioneers, early settlers, and residents, who labored with few resources but an abundance of determination and pride in their communities?

Not one to assume, I felt that it was my calling to compile this publication and bring to light the places, people, and institutions that paved the road for present-day DeKalb County. Today, DeKalb County is the second most affluent county in the country, after Prince George County, Maryland. Beautiful sprawling homes and million-dollar churches with congregations of over 20,000 members, such as New Birth and Cathedral of the Holy Spirit, line the streets. There is the unprecedented South DeKalb Church Federal Credit Union, comprised of the Ray of Hope Christian Church, New Birth Missionary Baptist Church, Greenforest Baptist Church, Big Miller Grove Baptist Church, Green Pastures Church, and Abundant Life Church. African-American–owned malls and businesses, including Baranco Car Dealership, First Southern Bank, and the South DeKalb Credit Union, are a part of the mystique of DeKalb County, the fastest growing county for African Americans in Georgia. But 30 years ago, DeKalb County was a different place.

As a child, I remember going to an annual cookout in Lithonia on the Clark's homestead. Little did I know that I would return to gather information about the family and area. The city of Decatur today bears no resemblance to the Decatur of 50 years ago, when downtown Decatur was in the shadow of an African-American community known as Beacon. Urban renewal and removal demolished homes, churches, and businesses once occupied by African Americans. A drive to Lithonia, Redan, Stone Mountain, Clarkston, and Tucker 30 years ago really meant a drive to the countryside, with sprawling farms, dairy pastures, and old plantations. Educational institutions were inadequate by most standards, but many of these one-teacher schools provided quality instruction.

Today, Decatur and other surrounding cities have grown and continue to grow with the leadership of astute past and current politicians, including Mayors Allison Venable, Elizabeth Wilson, Marcia Glenn, Chuck Burris, Congresswoman Cynthia McKinney, Senator Nadine Thomas, Dr. Eugene Walker, Vernon Jones, Honorable Thurbert Baker, DeKalb commissioners and public servants such as James Dean, John Evans, Hosea Williams, William Brown, Porter Sanford, other elected officials including Honorable Michael Hancock (the first African-American Superior Court judge for DeKalb County), and many more. Just 20 years ago only a handful of African Americans sought office—today African Americans outnumber the other candidates. DeKalb and Decatur chapters of fraternities and sororities, as well as the DeKalb Chapter of 100 Black Men and the DeKalb National Association for the Advancement of

Colored People (NAACP), all provide organizational stability.

I am blessed that this is the fourth title I have published through Arcadia. The research and documentation of African-American history in the city of Decatur and DeKalb County has been interesting and challenging. The two major challenges have been identifying and piecing together a history of a community in Decatur that is no longer physically evident, and offering ways to publicly recognize the history of African Americans in the city of Decatur and DeKalb County when so little currently exists. These challenges have not been mine alone, but of everyone involved, including the DeKalb Conventions and Visitors Bureau (DCVB), the DeKalb Historical Society, and the mayor's office, to name a few.

In 1985, the DeKalb Historical Society began an initiative to locate images of DeKalb County through the "Vanishing DeKalb Project," which produced a publication. That search yielded only a few images of the Beacon Hill community, including Herring Street School, Beacon Elementary, and Trinity High School, and they along with DeKalb College have worked feverishly to collect oral histories and artifacts so desperately needed in order to provide substance to this rich story. In 1996, the DCVB hired my company, Digging It Up, to research and develop strategies for further development of the county's history. Now, through the combined efforts of many, we are able to present a historical interpretive compilation, containing photo images, biographical sketches, historical timelines, and statistics. This pictorial history is a result of that research. Of particular note for the county seat, Decatur, the following was uncovered:

African Americans in the city of Decatur historically resided in an area formerly known as "Beacon Hill." In 1941, Allen Wilson Terrace, a public housing project, was constructed which replaced dilapidated housing. By 1964, Decatur's urban renewal program demolished most of the area surrounding the public housing project, which in the process destroyed a significant amount of African-American structures of that time.

Only three original African-American sites remain in Decatur, two of which are located on Robin Street: Lilly Hill Baptist Church and the former Trinity Presbyterian Church. The former Trinity High School building on Trinity Avenue, which has now been converted into an Arts Center and police precinct, is the only other remaining structure in that immediate vicinity.

Regrettably, there are no buildings or homes within this community that can be considered for historic designation. However, Mayor Wilson did unveil a historic marker designating the Beacon Hill community.

Because no publication is 100 percent complete, please note that this is not the definitive book on African-American life in DeKalb County. If there are omissions, please bring them to my attention. I would also welcome additional photographs. This publication is a collection of the following:

1. Sketches citing institutions and persons whose contribution to Decatur and DeKalb County before the 1970s should be noted publicly;

2. A chronological timeline of county events and activities to provide a historic frame of reference;

3. Images and research materials, which were obtained from newspaper articles, the DeKalb Historical Society, the Georgia Archives, personal family collections, and church collections.

A Brief Chronology of Significant Events for African Americans in DeKalb County

1823: The City of Decatur is chartered.

1830: There are 17 free African Americans in DeKalb County.

Roderick D. Badger, an African American, is born in DeKalb County. He is trained by his slave owner in the field of dentistry and works as an itinerant dentist traveling from county to county. In 1856, he moves from the Panthersville district of DeKalb to Atlanta, becoming the first African-American dentist in the city. During the Civil War, Dr. Badger serves as an aide to a Confederate Army colonel. He dies on December 27, 1890, and is buried in Atlanta's Oakland Cemetery.

1839: The First Baptist Church, originally known as Rock Mountain Baptist Church, is formed. By 1867, both whites and African Americans are members.

1840: Slaves are 10 percent of the population in DeKalb County.

1860: Slaves are a third of the population of the county. There are no free African-American residents.

1861: African-American slaves help build the Lithonia Baptist Church, whose congregation was exclusively white.

1868: Antioch A.M.E. Church is organized in the home of Sister Lou Bratcher, on what is now Electric Avenue. In 1874, a one-room structure was built on Herring Street (now Trinity Avenue). Later, the church moved to Marshall and Cooper Streets. It is now located on Atlanta Avenue.

Bethsaida Baptist Church is organized. After the Civil War, one of the church's early pastors, Rev. F.M. Simmons, and other African-American ministers meet with General William Tecumseh Sherman in Washington, D.C., to discuss the treatment of freedmen.

1870: The population of DeKalb County is 10,014, including 2,680 African Americans.

1879 : DeKalb's first granite quarry begins operation.

1882: Thankful Baptist Church is founded and is named for the Thankful Baptist Church in Augusta.

1884: Former slaves organize Mt. Carmel A.M.E. Church on Peachtree Road in DeKalb County.

1885: Rev. A.D. Freeman organizes Fairfield Baptist Church on Redan Road.

1901: Colonel George Washington Scott opens Scottdale Mill, built on a cotton field. He also builds mill houses and rented them for 25¢ a room.

1903: Frank H. Porter acquires property and 50 acres of land located at Covington and Kensington Roads for $1,000. This property was the ancestral home of Joseph Walker, a white, Southern plantation owner. Mr. Porter moves his furniture, chickens, and farm tools by mule, while his children walk, driving the cows.

1909: After graduating from Leonard Medical College, Ross S. Douthard moves to Decatur. He establishes his medical office at a house located on the corner of Marshall and Atlanta Street, becoming the first African-American physician in Decatur.

1913: Mother Hannah Burnett organizes the Lilly Hill Baptist Church in her home on East Lake Drive. Later, the church is moved to a tent on Electric Avenue and Robin Street. It is finally settled at Spring House on Atlanta Avenue and Waters Street.

Herring Street School is built for African Americans in Decatur.

1915: Ernest Moore, a runaway slave, jumps a train and later joins the Barnum Bailey Circus Minstrel Show as they travel throughout the United States and Europe.

1917: African-American soldiers are stationed at Camp Gordon, as part of the segregated brigade.

1926: Avondale Estates is incorporated. It is located east of Decatur and Atlanta, on Covington Road.

1932: Professor Charles Clayton, a 1914 graduate of Morehouse College, begins his tenure as principal of Herring Street School, which serves as both the elementary and the high school for African Americans in Decatur. He later receives his law degree and practices law.

1933: The Bryant family of Philadelphia becomes the first African-American family to move into the Cates Estate, later renamed Lynwood Park.

1941: Allen Wilson Terrace, a 200-unit public housing development for African Americans, is built in the Beacon Hill community. It was built as a United States Housing Authority Project for "colored" people. There were 21 buildings, with four to six units per building. There are three different sections, including Chewning Way, South and North Brooks Court, and Jackson Way. Income restrictions were placed on the occupants.

Cox Brothers Funeral Home, founded in Atlanta in 1900, opens a Decatur location on Marshall Street.

1942: Clarence Cooper is born in the Decatur Housing Project on May 5. In 1991 he is elected as a judge in the Georgia Court of Appeals.

1944: Narvie Jordan Harris, a Jeanes teacher, and later supervisor, organizes Jeanes schools throughout the county in churches, lodge halls, and old shacks. There are no school buses until 1950.

1945: After returning from the army, Lucious Sanders begins a voter registration drive in Lithonia.

The "Colored PTA" is reorganized and the first countywide Music Festival for "colored" schools is held.

1958: The Green Forest Baptist Church is founded with 135 charter members. Services are held in the Wadsworth Elementary School on Green Forest Drive.

1960: In May, Dr. Martin Luther King Jr. is stopped by police while driving in DeKalb County with author Lillian Smith. He is cited for not having a Georgia driver's license, fined $25, and placed on probation for a year. After his sit-in arrest a few months later, he is charged with violating his probation and is sentenced to four months in the DeKalb County jail.

In August, a DeKalb County candidate for state representative files suit against Lonnie King for conducting kneel-ins at local churches. King, who is employed by the postal service, could be enjoined under the Hatch Act, which has provisions against federal employees engaging in partisan political acts.

Two churches in Decatur with exclusively white congregations, Belvedere Methodist and Decatur Presbyterian, set aside specific pews for African-American students who should decide to visit the churches.

Twenty percent of Decatur's total population is African American, most of whom live in the Beacon Hill area.

The City of Lithonia builds a 75-unit public housing project.

In the 1960s, five African Americans sat on a grand jury in DeKalb County. They were the first since the Reconstruction period. Four of the known jurors were John Burnett, a roofer; Lincoln Jones, principal of Herring Street School; Columbus C. Jones, a railway porter; and Clifford D. Payton, a gardener.

1961: DeKalb voters approve a $3-million bond to build a new courthouse.

In April, students at Avondale High School publish a leaflet entitled "This Integration Brainwashing," which are placed in student lockers. The leaflet is an open letter addressing student rights regarding segregation. The Knights of the Confederacy are credited with distributing the letters.

1962: In March, the Decatur-DeKalb Regional Library allows African Americans to obtain books from its central library when books are not available at the Negro branch.

In June, the Decatur City Commission defers action on a request by Antioch A.M.E. Church to build a new church near Atlanta Avenue, an area that divides the African-American and white communities.

1963: In March, 40 people are arrested from a house on Kelly Lake Road in which racist literature, including Klu Klux Klan propaganda, is found. The house is allegedly being used as the headquarters for a an organization which calls itself the Central DeKalb Civil Association.

In July, the Candler Park Civic Association publicly denies that the area is slowly being integrated, even though the integrated swimming pool has more African-American than white swimmers.

1964: Eight percent of DeKalb County's 300,000 population is now African American.

The Tobie Grant Public Housing Project is built in the Scottdale area.

In March, the Decatur Housing Authority receives $1.8 million in federal moneys as part of the Beacon Hill Urban Renewal Project. The money is earmarked to purchase and clear 16 acres of the blighted residential area, in an effort to make way for the new Decatur High School.

In June, Willard Strickland and R.A. Knight, two former Atlanta police officers, become the first African-American policemen in Decatur.

In July, African-American residents threaten to file suit against DeKalb County if it fails to integrate its facilities. As a result, swimming pools, libraries, parks, recreation centers, and all other facilities in the unincorporated areas of the county become integrated. Prior to this action, DeKalb County had seven pools for white citizens and one for African Americans.

1965: Richard Wilson, the 11th-grade son of future Mayor Elizabeth Wilson, and 26 other students integrate Decatur High School.

1966: James Dean, representative of the 76th district, is the first African-American legislator elected from DeKalb County.

In September, many African-American residents in Lynwood Park face eviction from slum housing and seek assistance from the DeKalb Health Department and DeKalb County Housing Authority.

1967: In November, the College Heights Elementary School organizes a bi-racial Parent Teacher Association. Mrs. Clifford Wilson is president.

DeKalb County opens a new ten-story, 142,000-square-foot courthouse, on land once occupied by African Americans in the Beacon Hill community.

Trinity High School closes, and students merge with Decatur High School.

1968: On March 16, Tobie Grant, legendary psychic and businesswoman, dies. The funeral is held at the Wheat Street Baptist Church in Atlanta, and Grant is buried in Washington Park Cemetery.

In December, Eugene C. Maner Jr., a graduate of Morehouse College, is appointed administrative aide to the DeKalb County Commission Chairman. He is the first African American to hold an administrative position in the DeKalb government. His job is to coordinate the Manpower Development Program.

1969: The DeKalb Board of Education begins phasing out five of the six African-American schools in the county, including Bruce Street Elementary in Lithonia, County Line Elementary in Ellenwood, Lynwood Park, and Simmons Elementary in Stone Mountain. This action sparks a series of protests from the African-American community.

On April 26, a third protest against school closings ensued. Approximately 300 students from Hamilton High School marched to the DeKalb County Board of Education to deliver a petition, stating that "integration is a two-way street." Their

viewpoint on school integration is that it could also be accomplished by keeping Hamilton High School open, and allowing white students to attend.

In July, ten families move into Gateway Manor—a 6-acre urban renewal project that is a joint venture between private and public corporations.

In November, a DeKalb jury recommends that the county make the following improvements: hire 80 new policemen, build a new jail, furnish lockers and shower stalls, and issue a "non-biased financial report" every quarter.

In December, William H. Simmons and Sidney R. Holston, two African-American men, are among four candidates running to succeed City Commissioner Bob Carpenter. Simmons, a graduate of Florida A & M University, is a member of Lily Hill Baptist Church and member of the Decatur Colored Citizen League. Holston, a graduate of Albany State College, is a member of the Dearborn Park League.

DeKalb creates the "unitary system," which gives equal access to all citizens without regards to religion, creed, or color.

1970: In January, the United States Department of Justice files suit against a DeKalb real estate agency, citing a violation of the 1968 Civil Rights Act. The agency allegedly is refusing to show or sell houses to African Americans, except in all African-American transition areas.

The DeKalb County Concerned Citizens for Progressive Government is organized to represent the concerns of African Americans from predominately black neighborhoods, as well as to screen candidates for political office. State Representative James Dean, who also served as director of the Atlanta Urban League, organizes the group.

Decatur sanitation workers picket and demand an hourly pay raise from $2.10 to $2.45.

1971: The first African-American families move to the Flat Shoals section of south DeKalb County. White citizens of the area organize the Flat Shoals Alliance to create a harmonious, integrated neighborhood.

1972: Nate Mosby, president of the East Atlanta High School PTA, and Warren Cochran speak before the DeKalb County Commission regarding spending more county dollars on public health services for African-American residents.

1973: The Greater Travelers Rest Baptist Church, organized in 1876, relocates to Tilson Road, Decatur.

Al Venable becomes the first African American elected to the Lithonia City Council.

1976: William C. Brown, an educator and businessman, becomes the first African American appointed to the DeKalb County Library board of trustees. He is elected chairperson in 1978 and holds office until 1990. During his tenure on the library board, a $29-million bond referendum is passed to fund a $33.5-million library building and expansion program. Brown also served as a DeKalb County commissioner.

1977: St. Phillips A.M.E. Church, with a membership of 186 parishioners, relocates to the corner of Memorial Drive and Candler Road. Today the church membership is over 5,000.

1980: DeKalb County receives its first African Americans in the following offices: recorders, court judge, fire chief, assistant county attorney, and personnel director.

1982: John Evans is elected to the DeKalb County Board of Commissioners. Phil McGregor is elected to the DeKalb County School Board.

1983: On January 1, John Evans is sworn in, becoming the first African-American commissioner on the DeKalb County Board of Commissioners. Phil McGregor is elected as the first African-American DeKalb County School System Board member.

Therman McKenzie and Cornell McBride, two African-American DeKalbites and the founders of M & M Products, a manufacturer and distributor of black hair care products, celebrate the tenth anniversary of their company.

A federal judge orders the DeKalb County School system to admit more African-American students into Lakeside High School.

The DeKalb Lawyers Association is organized, to promote and encourage the professional development of minority attorneys.

1984: On January 7, Elizabeth Wilson is elected Decatur's first African-American city commissioner.

1986: Eugene Walker is elected as the first state senator from District 43 in DeKalb County since Reconstruction. In 1986, he was reelected and was voted as the majority whip for the State Legislature.

1987: Governor Joe Frank Harris names Linda Hunter the first African-American trial judge in DeKalb County.

Winston Bethel, Robert Borrough, and Michael Hancock organize the DeKalb Lawyers Association, comprised of African-American attorneys.

1990: Hosea Williams, civil rights activist, is elected to the DeKalb County Board of Commissioners with 82 percent of the vote.

Thomas E. Brown Jr. becomes the fire chief of DeKalb County, making him the first African American to ever hold the position. As fire chief, he managed 24 stations throughout the DeKalb County area, with over 480 firefighters and administrators under his command. In addition, he was in charge of the Fire Marshal's office and the arson unit.

In 1990, Chief Brown was appointed director of public safety in DeKalb County. This position involved the management of Animal Control, Emergency Medical Services, the Fire Department, Police Department, and 911 communications. Thomas E. Brown Jr.'s unyielding determination to achieve has made him one of the most important African Americans in DeKalb County.

1991: The *Champion Newspaper* is published by Earl and Carolyn Glenn (July 3).

The DeKalb Chapter of 100 Black Men is chartered (August 28, 1991).

1992: The DeKalb County Public Library Board of Trustees names the Wesley Chapel Library in honor of William C. Brown.

1993: Commissioner Elizabeth Wilson is elected Decatur's first female and African-American mayor.

1996 There are over 600,000 residents in DeKalb County.

Cynthia McKinney is elected as the first African-American woman to Congress from a majority white district.

Jeanette Rozier is elected as the first African-American clerk of Superior Court for DeKalb County.

Sidney Dorsey is elected the first African-American sheriff in DeKalb County. Nearly two thirds of DeKalb voters elect the former Atlanta police detective over the incumbent Bob Morris. A graduate of the Atlanta Law School, he had over 25 years of law enforcement experience and was a founding president of the Georgia Police Benevolent Association. His wife, Sherrie, was elected to the Atlanta City Council, serving the East Atlanta/DeKalb County section of Atlanta. They are the parents of two sons, Curtis and Justin.

1997: DeKalb resident Thurbert Baker is sworn in as Georgia's first African-American attorney general.

1998: In a 4-3 decision, the Supreme Court rules that the *Champion Newspaper* remains the legal organ for DeKalb County following a 25-year run by the *Decatur DeKalb News Era*.

One
DECATUR

"There was so much unity then. We were an extended family. I am proud of my background."
—Judge Clarence Cooper, 1994

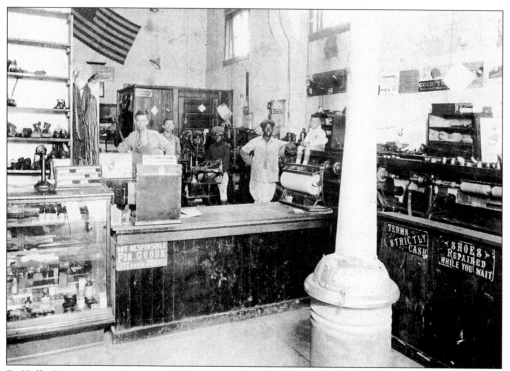

DeKalb County was Georgia's 56th county, founded in 1822. It was named for Baron Johann DeKalb, a German officer who fought and died with the American forces in the Revolution. DeKalb accompanied General Lafayette to help the American colonies in their struggle for independence from the British. Many of the early settlers of the county were English, Scottish, and Irish. A large majority were slaveholders.

The city of Decatur was named for Commodore Stephen Decatur, who helped to establish many United States Navy traditions. Decatur captured Tripoli but was killed in a duel during a court martial trial. By 1821, Creek Indians had ceded territory that would become DeKalb County. The following year DeKalb had a population of 2,500, created from the surrounding counties of Henry, Fayette, and Gwinnett. On December 10, 1822, the county seat was named for Decatur. The first post office was established in 1826, which was before the founding of Terminus and Marthasville, later to be known as Atlanta. By the first census in 1830, there were 8,388 whites, 1,669 slaves, and 17 free persons of color. (Courtesy of DeKalb Historical Society.)

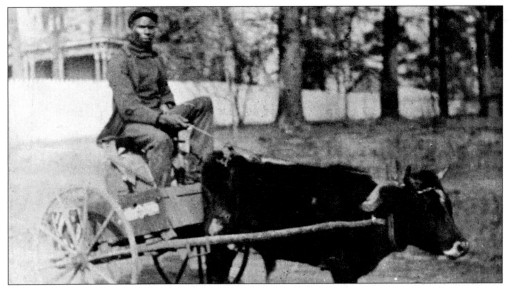

When Decatur was a small hamlet, Joe Osborn (pictured in front of the Candler's Home, c. 1890) traveled by oxen and cart, both supplying and lighting the oil lamps on the town's street corners. He carried with him five gallon cans of kerosene. Very little is known about Osborn. (Courtesy of DeKalb Historical Society Historical Photograph Collection.)

By the turn of the twentieth century, DeKalb County ranked 11th among top cotton-producing counties in Georgia. African Americans in the county were engaged in a variety of jobs, including rock quarrying, stone crushing, sawmills, strawberry patches, and dairy farms. Some of the leading dairy farms included the Cedar Grove Dairy, James Monroe White Dairy on White Mill's road, Fayette Clark Snow Dairy Farm, Early S. Payton Dairy, and R.L. Mathis in South DeKalb on Rainbow Drive.

One of the most colorful characters in Decatur's history was Nathaniel White, known as "Old Uncle Nat White." He was born a slave in DeKalb County, and during the Civil War stayed on the plantation while the slave master went to fight Union forces. Although "Old Uncle Nat White" often consumed too much alcohol, he was a kind and gentle man, rarely bothering anyone. Every policeman in the community knew him. Police officers tended to be kind when taking him into custody, in part because in their minds he was the town drunk and an amusing "darky," as the whites folks would refer to him. "Old Uncle Nat White" provided endless fun and laughter for the officers on duty at the jailhouse. He would put on a show by singing old Negro songs and dancing a few steps. He came to be the best-known, best-liked, and funniest prisoner of the DeKalb Police Department. (Courtesy of the Georgia Department of Archives and History.)

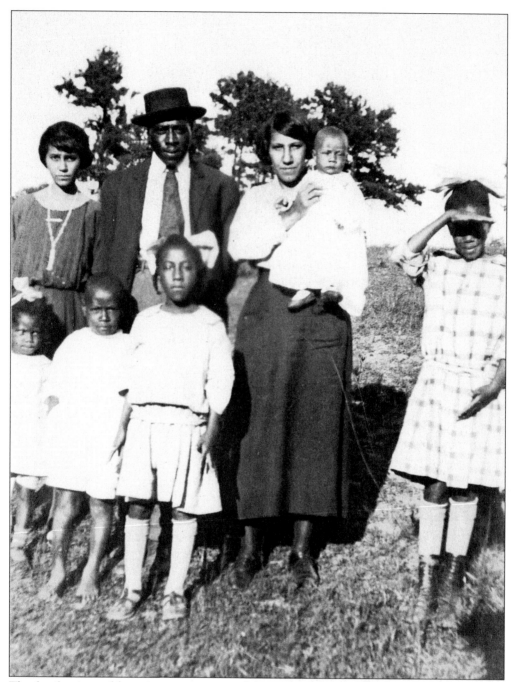

The family pictured here is representative of the many African-American families who, from the turn of the century to the 1930s, migrated to the small hamlet of Decatur from surrounding rural counties and settled in the town's black community known as Beacon Hill. While in many areas living conditions were substandard and below poverty, a sense of pride permeated the streets. (Courtesy of Skip Mason Archives.)

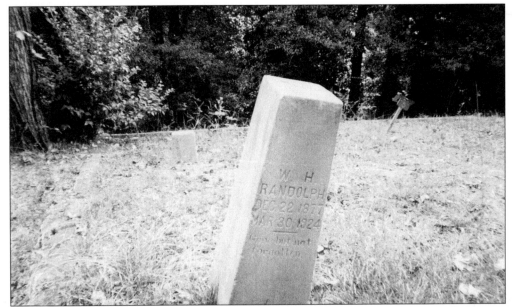

In the "Old Section" of the Decatur Cemetery, divided by a road and sitting down below the main section of the cemetery, are the graves of African Americans that date back to the early 1800s. A large number of the burials back then were carried out by African-American funeral homes, primarily Cox Brothers and Haugabrooks of Auburn Avenue in Atlanta, and later Tyler Funeral Home of Decatur. There are also a number of African-American war veterans from WW I buried in the cemetery. Some of the names in this section include Andrew and Marie Bowdre Jackson, the Thomas family, John and Bessie Tolbert and family, Jane and Myrtle Jackson, W.H. Randolph, Essie Reese, Rosa Davis, Benjamin and Lula Anderson, Jack Gaines, Stinson Little, the Stokes family, and the Patterson family. Many of the graves are unmarked.

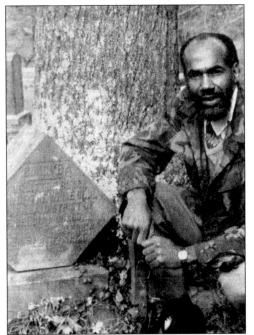

Perhaps one of the most famous persons to be buried in the Decatur Cemetery is a young African girl named Bukumbo. Bukumbo was brought to Decatur by local missionaries to nurse their child. However, she died at the tender age of 15. According to oral history, she sang Presbyterian hymns in her native tongue. Her grave is marked with a unique diamond shape headstone, with an inscription that reads, "Our little black pal of the white soul. She hath done all that she could do." Poet Ron Lee of Decatur (pictured above, next to Bukumbo's grave) wrote a tribute to the little African girl. (Reprinted from the *DeKalb News/Sun.*)

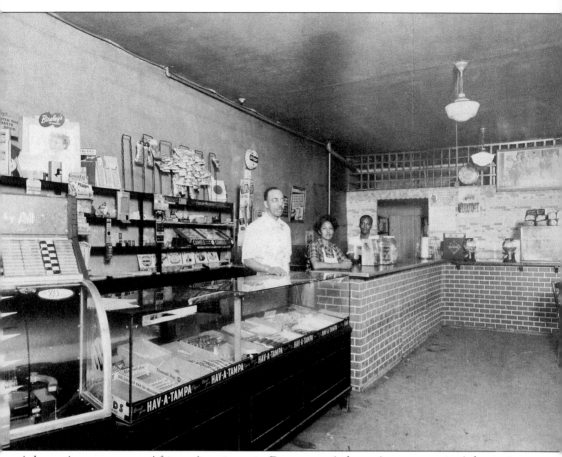

Atlanta Avenue was to African Americans in Decatur as Auburn Avenue was in Atlanta; it was a street where businesses flourished. According to oral history, it was once the Sandtown Indian Trail, an important Native American thoroughfare that ran from Stone Mountain to the Chattahoochee River. Some of the businesses on Atlanta Avenue included a dry cleaning firm owned by Archie Clark, restaurants operated by Eugene Jones, Clarence Clark, and Edward Levitt, the Ever Ready Cafe, Terrell and Steele Restaurant (Tom Steele), Edward Lee's Cafe, Otis Spates Rib Shack, Rogers Taxicab, Coopers Funeral Home, Star and Fisher Beauty Parlor, and Lena's Beauty Shop. Pictured here are Tom Steele, his wife, Ethel, and son Winfred Mills, (*c.* 1930) in his cafe. Splits were sold at both Tom Steele's and George Sterling's. At Tom Steele's, you could buy a split for 10¢, a Coke for 5¢, and a bag of chips for another nickel. Steele also served as a commissioner for the City of Decatur. George Sterling's Cafe was originally located on Marshall Street before moving to Atlanta Avenue. There, a split cost 15¢ (supposedly his splits were made of real meat and you could have lettuce and tomatoes in your sandwich). (Courtesy of Mollie Clark Mills.)

On the corner of Atlanta Avenue, across from the Thankful Baptist Church, was the Ritz Theater, a part of the Bailey Chain of Theaters. It was later renamed the Carver Theater. The Ritz opened in the early 1940s. Part of the police precinct now sits on the site of the Ritz Theater. Each Saturday, kids would flock to the "picture show" for a nickel and a Cappitola token. Cappitola tokens were found in the flour of the same name. Willie Dabney is pictured here, standing in front of the theater before the front facade was changed. Farther up Atlanta Avenue, where high rise apartments now stand, was the site of a crematorium, which was used for burning trash. Black smoke rising from the crematorium was a common sight. The Marta Train Tracks now run through what was Atlanta Avenue. Below, friends Pauline (left) and Lillie are standing on the corner of Atlanta Avenue. (Courtesy of Mollie Clark Mills.)

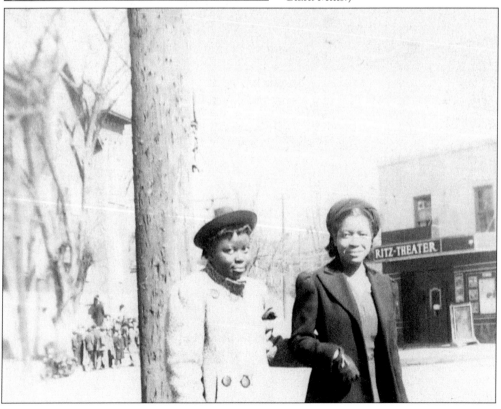

The Clark family of Lithonia, Redan, and Decatur has one of the longest and richest histories in DeKalb County. Luther Clark married Mollie Ragsdale, the daughter of Riley and Janie Benefield Ragsdale of Lithonia. They were the parents of Alma, Ola, Lula, Donnie, "Shug," Raymond, Charlie, Myrt, "Bud," and Mollie. Mollie and Luther Clark had four children: Alma, Archie, Janie, and Quinton. Archie Clark was born May 15, 1904, and attended Herring Street School before going off to attend school at the Tuskegee Institute. Archie married Dovie Dabney, the daughter of John and Josephine Alexander Dabney. The Dabneys were natives of Covington before migrating to Decatur. Dovie was born April 15, 1905. From left to right are as follows: Janie Clark, Mollie Ragsdale Clark, and Alma Clark.

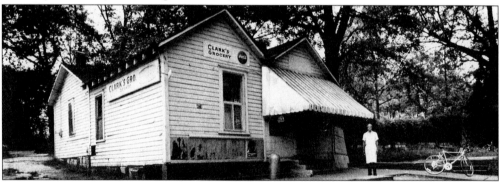

Archie Clark and his brother Quinton entered the business world during the 1930s when they opened Dry Cleaners and Pressing Club on Atlanta Avenue. The clothes were actually carried out to be cleaned and were brought back to the shop to be pressed. Across from the cleaners, Archie's mother, Mollie, operated a cafe known as "Miss Mollie's Café," which sold soul food. Following the death of Quinton Clark, who drowned in the Yellow River in Lithonia, Archie worked at the Decatur Laundry, located near the Depot. He and his wife moved from Atlanta Avenue to Forest Street (which was later renamed White Street), where they purchased a home on what would become one of Decatur's most affluent streets for African Americans. In a nearby house, WW I veteran Mr. Scott operated a wood and coalhouse, as well as selling candy and other confectionery. After Scott abandoned the business, Dovie Clark saw an opportunity and borrowed $50. With that money, she stocked the store with dry good items, washing powder, starch, and snuff. She even sold turkeys, which she raised on the family farm in Lithonia. As the business grew, her husband, Archie, quit his job at the laundry and together they operated one of the most successful businesses in Decatur. Mrs. Clark would often tell the story of how the business began, reminding everyone, including her husband, that she was the "founder." The store closed in 1978. Archie Clark died in 1985 and Dovie Dabney Clark died in 1994. (Courtesy of Mollie Clark Mills.)

The Clark family lived at the back of the store until they purchased land on White Street and built a home. White Street was the home of many old and distinguished African-American Decatur families, including the Kemps, Williams, Nellums, Jacksons, and Mosses. It was the street on which the Clark family raised their daughter Mollie.

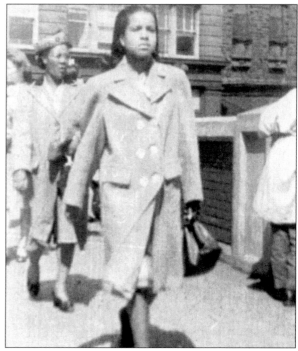

Mollie, shown here as a baby with her grandmother, Mollie Ragsdale, and as a teenager near the downtown Decatur Viaduct, attended Herring Street and the Lab High School on the campus of Spelman College. She married Winfred Mills, adopted son of cafe owner Tom Steele. Mills was an outstanding musician during the 1940s and played with many bands and in nightclubs in Atlanta and Lithonia. (Courtesy of Mollie Clark Mills.)

20

World-renown bandmaster Graham Jackson (center) is shown here with Decatur resident and musician Winfred Mills (right). (Courtesy of Mollie Clark Mills.)

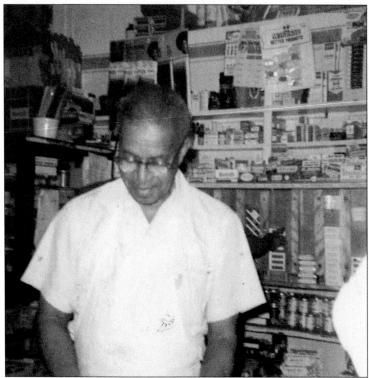

Archie Clark is seen here inside of his crowded grocery store on White Street, c. 1970. Clark operated the store until 1978. He died in 1985. (Photo courtesy of Mollie Clark Mills.)

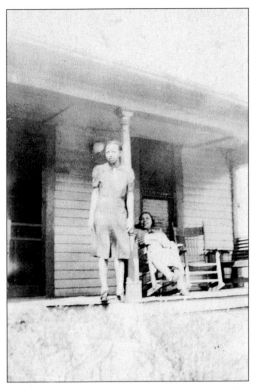

A glimpse of the 1945 Atlanta City Directory lists some of the following names of White Street residents: Trimble, Wilson, Copeland, Middlebrooks, Clark, Furlow, Harper, Hood, Jackson, Pollan, Smith, Bonds, Randolph, Hill, Kinsler, Bussey, Center, Steele, Fowler, Ebster, Sorrells, Williams, Blossingill, Millbrooks, Fears, and Reid—to name a few. Pictured to the left, seated in a rocking chair on her front porch, is Mrs. Virginia Fowler, who resided at 339 White Street, c. 1930. At the bottom left appears Mrs. Benjamin, a beautician and a resident of Robin Street. At the bottom right is Ms. Margaret Clopton with an unidentified girl. (Courtesy of Mollie Clark Mills.)

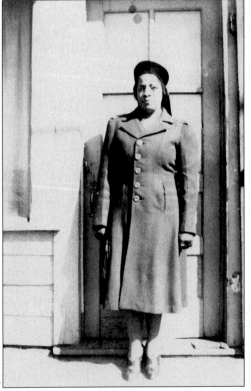

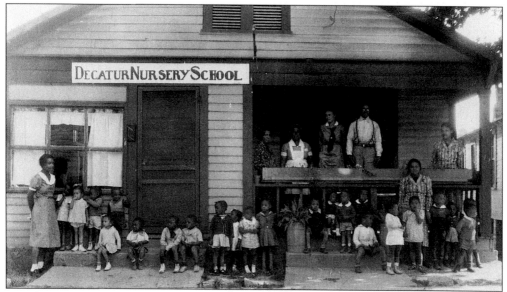

Now known as Trinity Avenue, the original Herring Street was the home of several important institutions within the Beacon Hill community of Decatur. By the 1920s several structures were demolished, including the St. James Presbyterian Church and the Odds Fellow Hall (which was located at the site of the present DeKalb County Court House). The office of Dr. Ross S. Douthard, Decatur's first African-American physician, was located in the building. Other buildings and businesses on the street included the Decatur Mission Kindergarten, Herring Street School (on the corner of Electric Avenue), Pearson Mason's Restaurant, and Pearl Crew, the first African-American dentist and nurse in Decatur. (Courtesy of Ross Douthard Jr.)

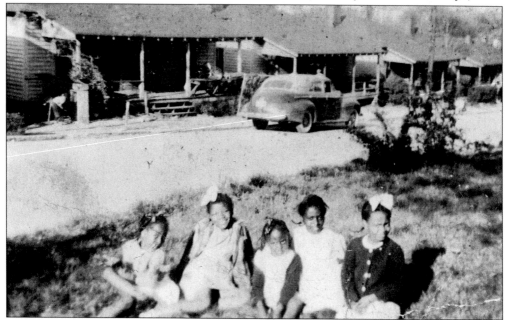

There were numerous families on Electric Avenue, including the Simmons family, whose home is pictured here in the 1930s. The house was typical of the structures of the homes in the community. (Courtesy of Annie Davenport.)

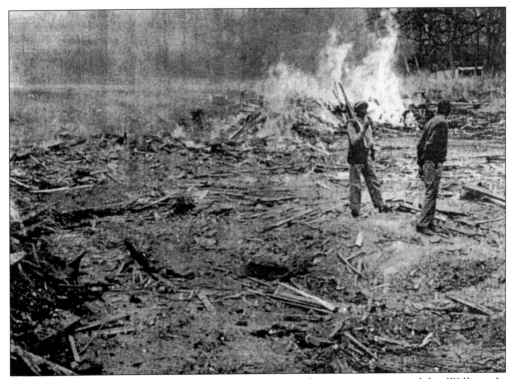

On the corner of Marshall and Herring Streets was the restaurant owned by William L. Snowden and Abraham Giddings, Warner King's Barber Shop, and Roscoe Sorrell's Cleaner. These and other businesses were completely wiped out during the urban renewal of the Beacon Hill community in the 1960s. Shown here is the vacant land following the demolition of the structures.

In October 1964, the City of Decatur hired its first African-American police officers—R.A. Knight and Willard Strickland (seen here). Both men had been employed by the Atlanta Police Department for a number of years and had successful careers. The police chief at the time, Luther Spinks, made the request in a letter, in which he wrote the following: "This letter is to request to employ two 'colored' police officers to police the colored section in the city Due to the spontaneous influx of population in DeKalb County and in the City of Atlanta, our crime rate and traffic have increased. In the first quarter of 1964, there were 61 calls from the African-American area . . . included 33 for disorderly adults and seven for disorderly children."

In Decatur, Knight and Strickland were given full policing power to arrest both white and black persons, unlike Atlanta's first eight African-American police officers in 1948. Both men represented the Decatur Police Department and the African-American community with honor and distinction.

WARRANTY DEED TO SECURE LOAN. Bennett Printing House, Atlanta.

STATE OF GEORGIA,
Fulton County.

THIS INDENTURE, made this 1st day of February in the year of our Lord One Thousand Nine Hundred and eight (1908) between Lena Harper of DeKalb County, Georgia of the first part, and Mrs Jennie A. Feagin of Muscogee County, Georgia of the second part:

WITNESSETH: That the said part y of the first part, for and in consideration of the sum of Three hundred & no/100 ———— DOLLARS,

in hand paid at and before the sealing and delivery of these presents, the receipt whereof is hereby acknowledged, ha S granted, bargained, sold, aliened and conveyed, and by these presents do es grant, bargain, sell, alien and convey unto the said part y of the second part, her heirs and assigns, all that tract or parcel of land situated, lying and being in the County of DeKalb and Said State of Georgia in the town of Decatur And described as follows: Fifty feet on Herring Street north, and running back (210) Two hundred and ten feet to the land of H.C. Austin on the South, thence East by the Land of J.C. Kirkpatrick formerly, now James Jackson, and on the West by Lands of the Colored School House and Odd fellows Hall, and on the north by Herring Street. Containing one fourth of an acre more or less. Same being the same land deeded to Lena Harper by William Stansell Jr on August 17th 1896. and recorded in Clerks office of the Superior Court of DeKalb County Ga.

According to oral family history, after the Civil War, a former slave Henry Oliver, born around the early 1830s, was given land by his master and father on Herring and Oliver Street (renamed Commerce Street) in the downtown area of the city of Decatur. A blacksmith by profession, Oliver, described as 5'8, small in stature, and very fair in complexion, owned a large tract of land and sold plots to both blacks and whites who were moving to the area. Oliver married Sylvia Clark, a descendant of the Clark family from Redan, Georgia, and they had four children: Annie Bell, Emma, Lena, and Eli. Pictured here is the deed of purchase of property on Herring Street by Lena Harper, daughter of Henry and Sylvia Oliver, in 1908. (Courtesy of Sylvia Kemp Clark.)

25

Left: Annie Bell Oliver married into the large Chewning family, for whom a street is named in Beacon Hill.

Bottom Left: Another Oliver daughter, Lena, did laundry for white families on Candler Road and would walk up and down the street twice a day.

Bottom Right: During one of her daily walks on Candler, Lena met Samuel L. Harper, a contractor. He was building the steeple on the Bell tower at Agnes Scott College. (Courtesy of Sylvia Kemp Clark.)

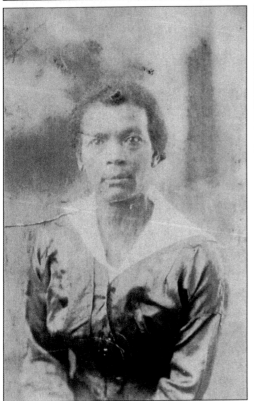

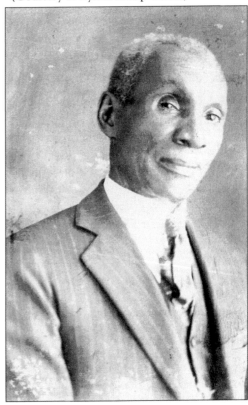

Samuel L. Harper built a home in 1896 on the site of the public housing projects, and his family remained there until 1941, when the homes were demolished to build the Allen Wilson Public Housing projects. His father-in-law, Henry Oliver, died around 1904 and is buried in the Decatur City Cemetery with his wife. Oliver Street was named for him, but has since been renamed Commerce Street by the DeKalb County Board of Commissioners. (Courtesy of Sylvia Ann Kemp Clark.)

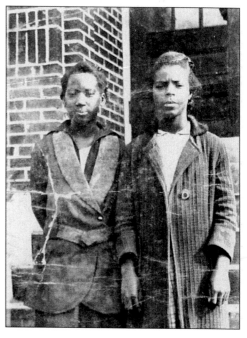

Lena Harper (left), pictured with classmate Janie Brightwell, attended Morris Brown University in the early 1920s, which was then located on Houston Street and Boulevard. Lena rode the trolley from Decatur every day to attend classes. She graduated from the high school department in 1922, but found difficulty obtaining a job. She later married Arthur Kemp and moved to White Street, where they raised their two children, Sylvia Ann and William Heard. Mrs. Lena Kemp also wrote the history of Antioch A.M.E. Church, where she was a faithful member until her death in 1984. Her daughter, Sylvia Ann Kemp Clark, a talented and gifted artist, has preserved much of the history of her beloved Decatur community through sculptures and paintings. (Courtesy of Sylvia A. Kemp Clark.)

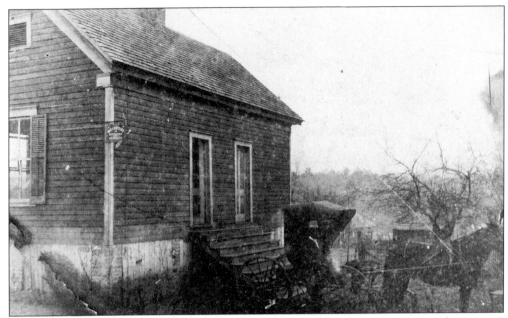

Dr. Ross S. Douthard Sr. (bottom right photo) was the first African-American physician in Decatur, Georgia. Born in Greens County, Alabama, in 1877, he attended Anderson Industrial High School in Anderson, Alabama. From there he matriculated at Leonard Medical College (at that time college was not a prerequisite for medical school). Dr. Douthard graduated from medical school in 1908 and a year later moved to Decatur, Georgia. He set up a practice in an office near Marshall Street and Atlanta Avenue (pictured above). His fees were modest, 25¢ for an office visit and 50¢ for a house call. In the early 1900s, physicians fought diseases caused by unsanitary conditions, ineffective drugs, and inadequate heating of schools and homes. According to oral history, Dr. Douthard diagnosed an epidemic of typhoid fever at Agnes Scott College in 1913. Dr. Douthard Sr. was a pioneer of professional excellence and a tribute to the African-American heritage of Decatur. He is also shown here in the bottom right photo with his wife. (Courtesy of Ross Douthard Jr.)

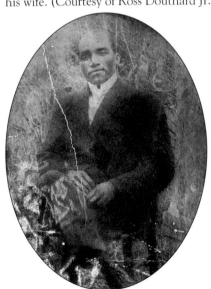

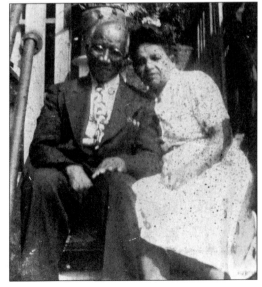

Picture here are the members of the 50/50 Social Charity Club, c. 1940s. (Courtesy of Mollie Clark Mills.)

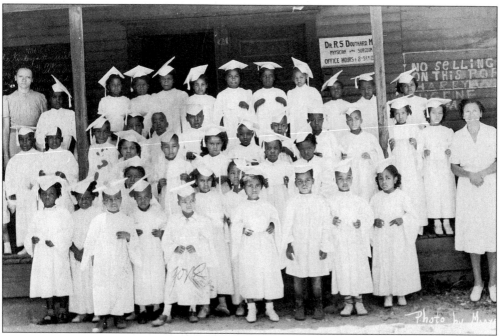

William Heard (third row, third from left) is shown with members of this 1940 kindergarten class. They are posing for the camera in front of Dr. Douthard's office on Herring Street with their teacher, Mrs. Zelma Lowe Scott, one of three Lowe sisters who lived in Decatur. (Courtesy of Sylvia Clark.)

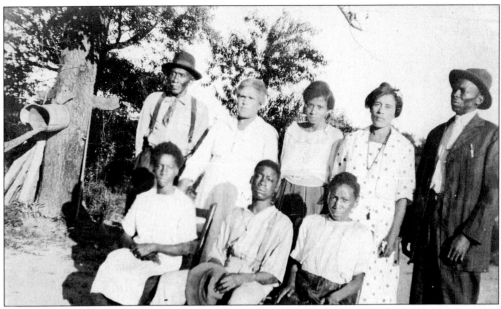

These are two unidentified early images of African Americans in Decatur's Beacon community c. 1910.

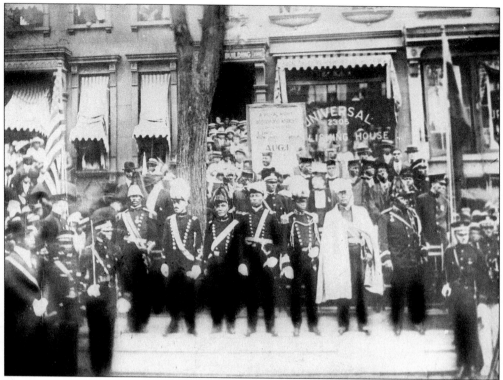

No one would have imagined that by 1926 there would be a Decatur division of Marcus Garvey's Universal Negro Improvement Association (UNIA). Many of the Georgia Garveyites worked as tenant farmers. UNIA members were still very loyal to Garvey despite his being imprisoned at the Federal Penitentiary in Atlanta in 1924 for mail fraud. Georgia had at least 34 local units, and the newspaper the *Negro World* was circulated throughout Georgia. (Courtesy of Herman Reese.)

When people went to town they would often say they were going "Up in Decatur." Black folks would sometimes go to the segregated Miss Georgia's Ice Cream parlor. A trolley car could be taken to downtown Atlanta, where one could go to Yates and Milton Drug Store and the Royal Theater on Auburn Avenue. There was once a lady named Ella Carey, who cleaned tables at Agnes Scott College. She wore an apron with deep pockets and would take sugar and empty it into the pockets. She would tell her neighbors in the Beacon community to come to her house, but not until nighttime, to get some sugar. Folks would line up just to get some sugar to put in their coffee or other items that needed sweetening. DO YOU REMEMBER? Bennetts Alley, Hunter's Alley, Water Street, Barry Street, Ozmor Street, Elizabeth Street, Boswell Street, West Brooks Court, North Brooks Court, South Brooks Court, Painters and Plasters (Luke Hillman, Sam Starr, Dick Jackson, Eddie Flint, and Rochell Wilborn), John Burnett Roofers, Frank Kendrick Plasters, Barbers-Kilgore Barber Shop, Louie Barber Shop, Lena's Beauty Shop, Gay's Beauty, William Beauty Shop, Benjamin Beauty Shop, Jake Russ Grocery, Spicks Grocery, Mossman Grocery, Barnetts Cafe, the Golden Gospel Singers, and Rogers Cab Company.

Pictured is the home of Henry and Annie Davenport at 426 Robin Street. Several churches were also on the street, including Lilly Hill Baptist Church, Robin A.M.E. Church, and the Trinity Presbyterian Church and nursery. Other residents of Robin Street included Richard and Hazel Briseay and Susie Calhoun. There were many families on Robin Street. The 1935 Atlanta City directory lists some of the residents: Sarah Williams, Jessie Daniel, Leotus Phelps, Clarence Cooper, Claude Blossomgive, William Smith, Mary Stevens, Essie Flanagan, Moses Ray, Hattie Showers, Cora Ivy, William Hardeman, Eugene Martin, Jerry Fears, Laura Phillips, William Brown, Green McKnight, Albert Jones, James Duncan, Tobe Richardson, Lizzie Giles, Oscar Reid, Samuel James, Henrietta Carter, Asbury Smith, Exie Strong, Viola Middlebrooks, and Jack Bailey. (Courtesy of Annie Davenport.)

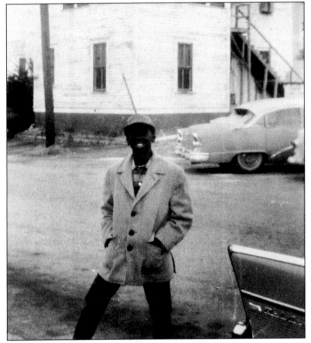

An unidentified young boy stands on Marshall Street, *c.* 1940. Several businesses were located on Marshall Street, including William Snowden's restaurant, Warner King's barbershop, Roscoe Sorrell Dry Cleaning, and Abraham Giddings Restaurant. Dr. Douthard also resided on the street, as well as other families, including the Martins, Simmons, Hopes, Griffeys, Kilgos, Andersons, Griffins, Richardsons, Isbell, Echols, Jeffries, and Finestones—to name a few. After crossing Atlanta Avenue, it was primarily a white residential area. (Courtesy of Annie Davenport.)

Also located on Marshall Street was the Cox Brothers Funeral Home. The business started in Atlanta, Georgia, in 1900, under the ownership of Emily Cox and her sons, Allen and Charles. The business expanded rapidly, with the Decatur branch opening in 1941. The Cox family attributed part of their success to fair and honest business practices. They established an association for uninsured families, who could join and pay small sums each month, in order to provide proper burials. Several people worked at the Decatur branch, including Ann Chewning (right), a well-known resident of Decatur. Located upstairs in the building was the office of the Jeanes Schools supervisors. In the 1960s, during the urban renewal period, the Decatur funeral home was demolished. The Jeanes office was relocated to another school before it moved to the DeKalb Board of Education office.

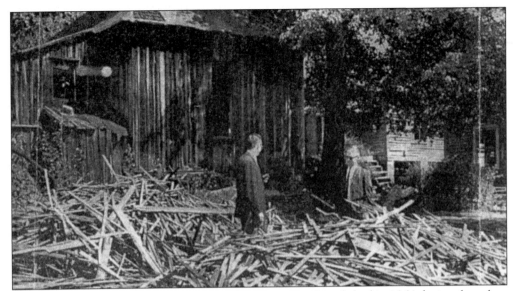

Homes in the African-American section of Decatur were demolished in 1964 during the urban renewal of the area. Swanton Heights, an apartment complex, was built adjacent to the Allen Wilson Terrace Apartments. The complex was named in honor of Benjamin Swanton, who once owned the land in that section. The 93-unit housing project was part of a $2-million urban renewal plan, which demolished several streets in the community. The remaining streets that make up the perimeters of Swanton Heights and the Allen Wilson Apartments are West Trinity Place, Commerce Drive, Robin Street, and Electric Avenue. The original housing projects were named for Reverend Allen Wilson, pastor of the Presbyterian Church.

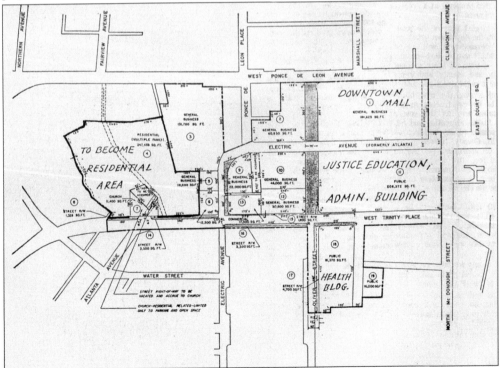

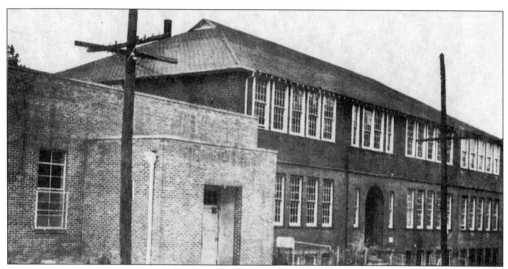

Prior to 1902, there was no public school for African Americans in Decatur. Those who could afford it attended a small parochial school in the Presbyterian Church, with Rev. A.A. Wilson and his wife serving as teachers. D.G. Ebster recalls that Rev. Lewis Thornton was his first teacher and whipped children during "those days." There were no desks, tablets, or ink—just a slate. Nearly all of the students brought their dinner to school in tin buckets. Herring Street School, established in January 1902, was the first public school for African Americans in Decatur. Originally located in a lodge hall, the school consisted of two teachers, Mr. S.T. Redd as principal with a salary of $30 per month and Miss Nellie Crawford, his assistant, who earned $20 per month. The school carried six grade levels and 102 students. (Courtesy of Cynthia Houston.)

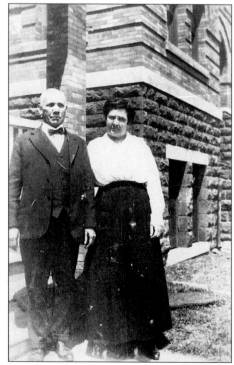

Mr. Redd stayed at the school only one year, and in 1903, Mrs. Clara Maxwell Cater Pitts (pictured here with her husband, C.C. Cater) was appointed principal. From 1902 to 1909, enrollment at the Herring Street School grew. The school was moved to a larger site located on Herring Street, hence giving the school its name. As enrollment increased, double school sessions began. In 1913, construction of a new brick structure began. The faculty began increasing and had reached eight by 1939. The eighth grade was also added, creating a "high school" atmosphere for older students.

In 1916, Rev. A.A. Wilson, having discontinued the parochial school due to a sharp decrease in enrollment, was appointed principal and remained with the school until his death in 1929.

In September 1929, Charles Maxey became the principal of the Herring Street School, and the school's enrollment continued to increase. Unfortunately, principal Maxey met a tragic and untimely death.

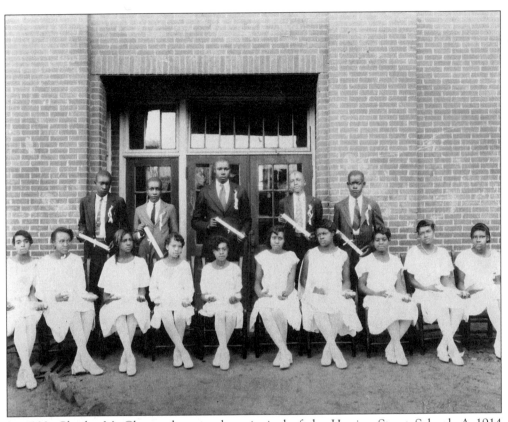

In 1932, Charles M. Clayton became the principal of the Herring Street School. A 1914 graduate of Morehouse College, Professor Clayton taught at the Sylvia Bryant School on Auburn Avenue. Under his leadership, the Herring Street School continued to prosper—enrollment increased, teachers were added, salaries increased, portable buildings were erected, activities were added to the school's program, and a functional Parent Teacher Association (PTA) was organized. Clayton immediately saw the need for a high school, so he formed a committee of citizens and presented their plan to the board of education. Superintendent Lamar Ferguson and the board consented to add one grade per year. Tuition was $1 per month. The first graduation was held in May 1936 with five graduates: Mary Oneta Chandler, Rosa Mae Hicks, Dorothy Frazier, Mary Lousie Reese, and Grover Cleveland Willis Jr. After completing the eighth grade, many Decatur students attempted to enter the Atlanta Public Schools by giving false addresses of a residence in Atlanta. After the Atlanta School Board discovered this, they asked the City of Decatur to pay tuition for these children. Later the tuition fee was omitted for students living in Decatur. However, the elementary school attracted children from other areas in the county who had to pay the tuition.

In 1945, $2,500 was raised to fund a football team, and $1,200 was raised for the first band in Decatur for African-American students, under the direction of Earl Starling, a native of Jacksonville, Florida, and the assistance of Eddie Page. According to Professor Clayton, faculty, students, and the Lions Club of Decatur raised the funds. The first majorette was Jennie Cobb Weldon. In 1953, Page became the first full-time band director until 1954, when Mr. Mason P. Johnson joined the faculty. Other support for these extracurricular activities came from white citizens, such as Mayor Scott Candler; Dr. McCain, president of Agnes Scott College; Judge James Davis; and Superintendent O.L. Amsler, who donated $150 to support the band. (Courtesy of Mattie Espy.)

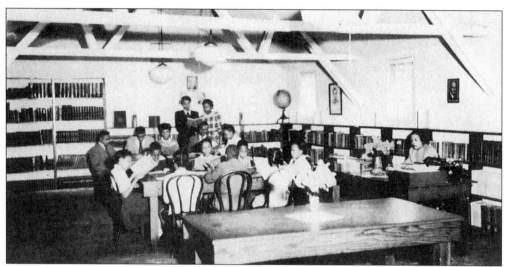

In 1948, the first Herring Street yearbook, *The Herrington*, was published under the direction of Georgia B. Brooks. It originally sold for $2.50 a copy, but was later reduced to $1.50 to increase sales. The book chronicled many aspects of the school, including the school's library (pictured here), managed by Mrs. A.E. Weathers. (Courtesy of Cynthia Houston.)

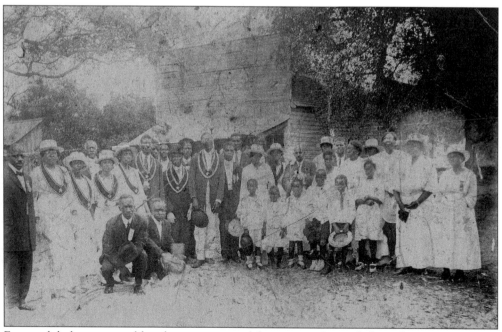

Fraternal lodge groups, like the one pictured here, were located throughout Decatur and DeKalb County, including the Prince Hall Masonic Lodge Free and Accepted Masons. Sister lodges were also prevalent, including the Eastern Stars and the Daughters of Calanthe. (Courtesy of Skip Mason's Archives.)

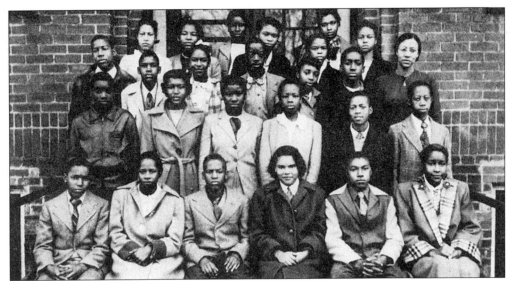

Members of the 1948 eighth-grade class at Herring, from left to right, are as follows: (first row) Floyd King, Betty Hardeman, Willie Lyles, Mary Radford, James Jackson, Lelia Walker; (second row) Harvey Perryman, Nina Marks, Alberta Wilborn, Martha Brown, Carl Earl, Claude Bailey; (third row) Cleveland Grier, Julius Shaw, Johnnie Stafford, William Lawrence, Ethel Williams, William Heard; (fourth row) Mattie Armour, Mary Barnes, Betty Robinson, Jason Smith, Katie Smith, Sadie Thompson, and Mabel Jean Strickland.

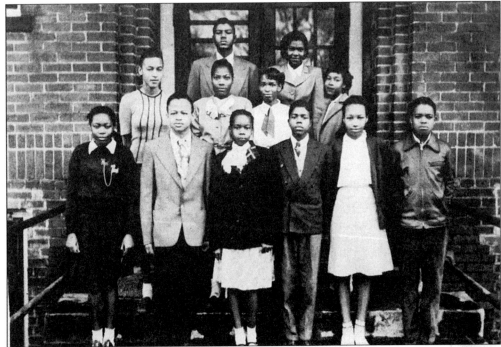

The sophomore class of 1945, from left to right, are as follows: (front row) Irene Davis, Vernell Robinson, Dorothy Polain, John Champion, Barbara Williams, Johnny Burnett; (middle row) Clarice Shields, Laura Adams, Sarah Tolbert, Eunice Carr; (back row) Ernest Brown and Kay Frances Ferry. (Courtesy of Cynthia Houston.)

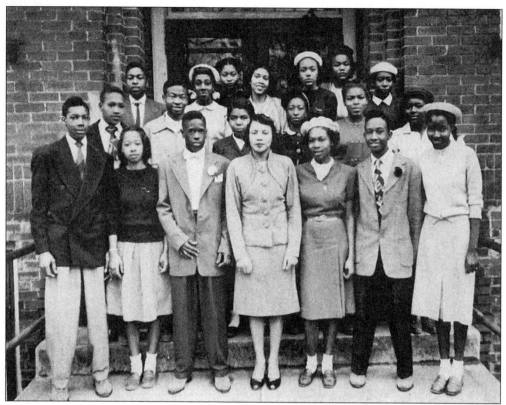

The junior class of 1945, from left to right, are as follows: (front row) Henry Poythress, Myrtice Bennefield, Carl Smart, Mrs. Cox, Gloria Baker, Ray Grimes, Louvenia Fowler; (middle row) Charles Flint, Thomas Choates, Helen Moss, Walter M. Freeman, Katie Johnson, Dorothy Perryman; (back row) Richard Reed, DeLoya Brooks, Frances Rowe, Lillie Rowe, Joan Perkins, Corene Evans, and Helen Jordan. (Courtesy of Cynthia Houston.)

In this c. 1945 photograph, the Herring Street cheerleaders, from left to right, are as follows: Julia Wilson, Susie Kinsler, Missouri Flint, Luvenia Fowler, Gloria Baker, and Zenobia Jordan. (Courtesy of Cynthia Houston.)

By 1953, Herring Street School had nearly become two separate entities. Professor Clayton decided to pursue the field of law. Mr. A.J. Martin became the principal of the high school section, and Mrs. Sara T. Blackmon was the principal of the elementary school. In 1955, the school became two separate schools and was renamed Beacon Elementary and Trinity High School.

From 1902 to 1955, the Herring Street School served the African-American population of Decatur well. Its contribution to society is evident in the numerous doctors, lawyers, engineers, and other positive citizens it helped produce.

After ground breaking on February 14, 1955, during one of the coldest days to be remembered, in 1956, a new structure was erected and named for Trinity Street, thus becoming Trinity High School (seen here). While the school was being constructed, classes were held in two homes which had been converted to classrooms to house the students. When the building opened, the elementary school was moved adjacent to the new high school and renamed Beacon, a name selected by the students. Beacon would operate until 1977. The year 1955 marked the last graduating class of Herring Street School, and the Herring Street Bulldogs placed first in the district and North Georgia Championship.

From 1956 to 1967, Trinity High School served as a cornerstone of the African-American community in Decatur, with many of its graduates going on to become great men and women. But even with the new school, Mayor Elizabeth Wilson recalls that there was no equipment, lockers, lab equipment, home economics stoves, athletic gear, or band uniforms like that of neighboring Decatur High School. Through street fairs, selling of candy apples and such, some funds were raised. (Reprinted from Trinity High School Yearbook, 1963.)

Left: Professor Charles M. (Fess) Clayton entered the Decatur School System in 1932 as the principal of the combined schools: Herring Street Elementary and High School. During his long and distinguished tenure with the Decatur School System, Professor Clayton was a teacher, administrator, and mentor for three generations of Decatur schoolchildren. Though known as a strict taskmaster and disciplinarian, he also taught young African-American students that the road to success in life is difficult but is made easier through education.
Right: The well-known principal of Trinity was Mr. A.J. Martin, who arrived in 1953. Martin also owned and operated a restaurant in Atlanta called the Shrimp Boat on Simpson Street.

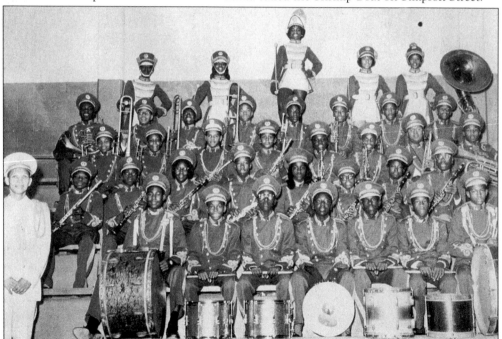

Band director Mason P. Johnson, a famous musician who performed and entertained during Atlanta's entertainment heyday, from the 1930s to the 1960s, arranged the Alma Mater of Trinity. Johnson is shown here with the Trinity band *c.* 1964. (Reprinted from Trinity High School Yearbook, 1963.)

41

The Trinity High School Class of 1959 files into the Decatur High School gymnasium for Baccalaureate exercises. From left to right are the following: Chevine Jones, Edward Welch, Aleen Holliman, and William Frank Meadows.

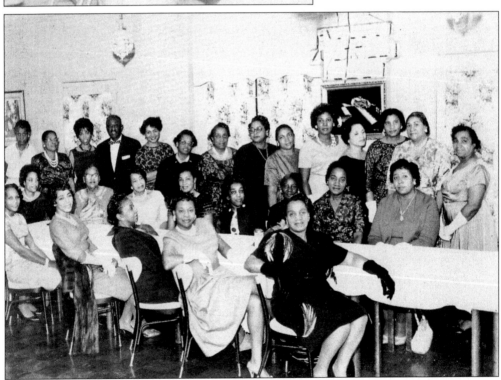

Members of the Trinity High School faculty are enjoying a luncheon in honor of retiring teacher Mrs. V.R. Taylor at Frazier's Cafe Society on Hunter Street on the west side of Atlanta. Many former Decatur residents echo that Mrs. Taylor, along with these other teachers, were some of the most dedicated and admired educators. They had very little resources but were exceptional teachers. (Courtesy of Pauline Morgan White and Genelle Hollis.)

Since 1989, the Herring/Trinity Alumni Association has been sponsoring annual reunions. Cynthia Houston has served as secretary of the association. Born in Decatur to Ben and Maggie Johnson Brown at 311 White Street, she has been actively involved in the reuniting of former Beacon residents. Houston came from a long line of active women, including her aunts, Ruby Williams Moss (pictured here) and Rosetta Williams, one of the first organizers of the DeKalb branch of the NAACP. (Courtesy of Elizabeth Wilson.)

Born on April 2, 1915, to Mr. and Mrs. Ben Williams, Rosetta attended Herring Street School, Bryant Preparatory Institute on Auburn Avenue, David T. Howard High School, and the Beaumont School of Nursing. She was a longtime member of the Thankful Baptist Church, where she joined under Reverend Jackson before later joining the Boulevard Seventh Day Adventist Church in 1987. It was her activity and commitment to the NAACP that carved her legacy. Before the 1950s, the organization was called the "Movement." It was necessary to disguise the name to avoid harassment from local whites. Ms. Williams was a private duty nurse until her retirement. Then she opened the Williams Personal Care home for the elderly in DeKalb County. She died June 25, 1997, and was buried in Washington Memorial Gardens.

IAMES ADAMS MICHAEL ANDERSON GILBERT ARMOUR HAZEL BAILEY JACKIE BAILEY WILLIE E. BAILEY REGN

VONNE COOPER TERRY T. DAVIS MRS. G. B. BROOKS
ADVISOR

Trinity
High School
Class of
19 67

CONSTANCE E. GOLPHIN

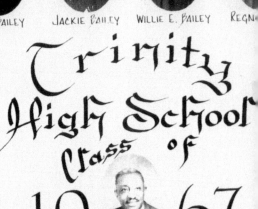

MR. A. J. MARTIN
PRINCIPAL

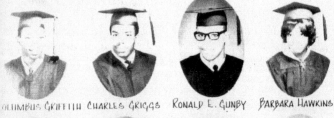

OLUMBUS GRIFFITH CHARLES GRIGGS RONALD E. GUNBY BARBARA HAWKINS HERMAN L. HOWARD REATHIA HOWARD ALFRE

HIRLEY MATHIS BEVERLY J. MITCHELL ELOISE ORR DORIS PARKER CHARLIE PIERCE CORA PRICE CLAREN

JOANNE STEPHENS RAYMOND STOCKTON ROBERT TATE HARRY SHANKS JOE THOMAS WILBUR THRASHER GLENN

44

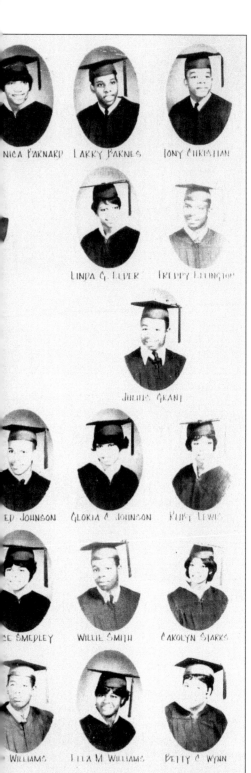

NICA BARNARD LARRY BARNES TONY CHRISTIAN

LINDA G. ELDER FREDDY ELLINGTON

JULIUS GRANT

ED JOHNSON GLORIA A. JOHNSON RUBY LEWIS

E SMEDLEY WILLIE SMITH CAROLYN STARKS

WILLIAMS ELLA M. WILLIAMS BETTY C. WYNN

This composite shot is of the last graduating class of Trinity High School. During the 1960s, there were 11 schools in the city of Decatur, 9 elementary and 2 high schools with a total of 4,200 students, of which 20 percent were African Americans. African-American residents primarily lived in four areas of the city, with the "Beacon Hill" community comprising the largest number. African-American children attended either Trinity High School or Beacon Hill Elementary School, both located in Beacon Hill.

In 1965, because of federal requirements for school integration under the Civil Rights Act, Decatur's school system dispatched a Plan of Compliance. Under this plan, students entering the Decatur school system for the first time could apply to attend a school in the area where he or she lived. There were 31 elementary-age African-American children living on the east side of the city, in the "Sams Crossing" community. Six more lived just north of Decatur Cemetery, with another four on Madison Avenue near Kirkwood. Under the integration policy, these pupils qualified to register at nearby white elementary schools—Glennwood, Winnona Park, Clairmont, Oakhurst, or Fifth Avenue.

For students already enrolled in school, they could continue attending their present school, or request a transfer to a school located in the geographical attendance zone where he or she lived. Additionally, students could also request a transfer to another school to take a course of study, "for which he is qualified and which is not available in the school he is attending." With the exception of Latin, the same courses were being taught at both Trinity and Decatur high schools, predominately black and white respectively. Initial integration of Decatur's schools touched only three or four schools. In 1965, a new high school building was built on the site of Girls' High. Black and white students entered the new school to begin a new era of integrated education. A total of 26 African-American students were enrolled in Decatur High School in 1965 amidst racial tension and slurs, but no major outbreaks of violence occurred, unlike the Little Rock High School Integration of 1958. Trinity High School closed in 1967. (Courtesy of Elizabeth Wilson.)

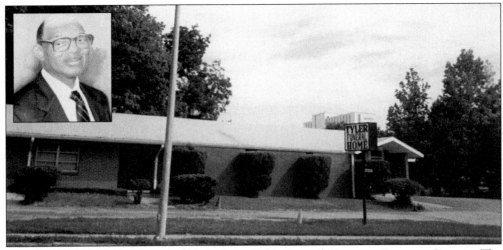

In 1951, Johnnie L. Tyler Sr. established the Tyler Funeral Home in Decatur, Georgia. The original site was located in the heart of Decatur's African-American community, in a white house at 509 Atlanta Avenue. The latter building was constructed during the 1960s and sits near a former sawmill located on Water Street. The area was also used for carnivals.

Since there were no emergency medical services (EMS) available during the 1950s for African Americans, Tyler Funeral Home served as the primary source for emergency transportation to various hospitals and clinics. It has served the African-American community of Decatur for many years and is one of the oldest operating African-American businesses in the city of Decatur. Tyler Funeral Home has, and continues, to set high standards in the mortuary business. Tyler's son now operates the funeral home at 511–13 West Trinity Place.

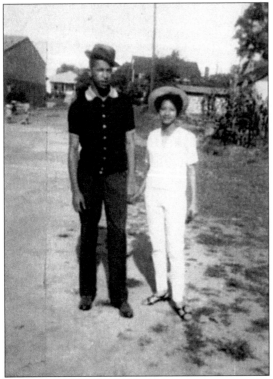

Ebster Park, located between Robin Street and Electric Avenue, was named for one of Decatur's pioneer families. Mrs. M.A. Ebster, wife of Deacon E. Grant Ebster, helped to organize the Herring School PTA. The Ebsters were upstanding citizens of Decatur, as well as long-standing, faithful members of the Thankful Baptist Church. Mrs. Ebster's father-in-law, "Deacon" J.H. Ebster, wrote a historical account of the Thankful Baptist Church, expressing the wonderful role that the church played in Decatur's African-American community. J.H. Ebster became noted, in DeKalb County, as an author and great storyteller. Other Ebster family members included Nicy, the mother, Luke, an older son, and younger twins, D.G. and Joe. The Ebsters resided on both Herring and White Streets. Pictured here, Bobby and Jacquelyn Welch stand in the middle of Ebster Park c. 1960.

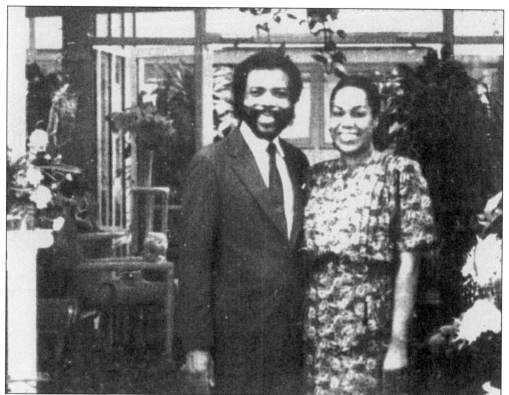

James L. Bussey (shown with his wife, Alice, c. 1989) is known locally and internationally as a highly successful florist. His reputation for turning ordinary ceremonial occasions into a floral fantasy is unparalleled. Flowers have long been a part of the Bussey family, who were longtime residents of Decatur's Beacon Hill community. Jeff Bussey, James Bussey's uncle, had been employed in Atlanta flower shops all his life and became a well-known floral designer. In addition, both James's father and grandfather dabbled in the flower business over the years.

In 1955, at age 13, James began working for the Gatlins. He tended the garden of Ida Mae Gatlin, the wife of a butcher, and later helped out at the Gatlins concession market located in the Municipal Market of downtown Atlanta. Here he learned to cut meat and arrange flowers, which later became the primary business of the Gatlins. After spending six years, all of his high school days and two years of college, working for the Gatlins, James decided that he no longer wanted to work for someone else. At the same time, he also decided to leave his French and psychology studies at Morehouse College and devoted all his time and energy into creating his own business. He began operating a floral business from his parents' home, growing the flowers in the backyard.

By 1965, business had grown enough for him to move into a small shop on Marshall Street in downtown Decatur. Due to the on-going urban renewal project, which demolished the entire business district of Decatur, he relocated to College Avenue, on the border of Decatur and Atlanta.

In 1975, James Bussey married Alice White, whose family had roots in Ellenwood, Georgia. He not only gained a partner in life, but also an exceptionally skilled and politically knowledgeable business partner. Alice Bussey was the first woman to be elected president of the Atlanta Business League. She was also elected a Georgia delegate to the 1986 and 1995 White House Conference. Over the past 30 years, Bussey's Florists has grown from a local retail operation into an international one, doing business all over the world.

These were two of Decatur's leading businessmen, Thomas W. Steele (right) and Grover Ferrell (left). Thomas W. Steele, proprietor of the Deluxe Cafe, also served as a city commissioner for the City of Decatur. Grove Ferrell lived "over in the bottom." (Courtesy of Mollie Clark Mills.)

Skating was a popular pastime for children in Decatur. Shown on skates in the Allen Wilson Terrace Apartments during the 1930s are, from left to right, the following: Maggie Fowler, Willie Dabney, and Josephine Dabney. (Courtesy of Jakki Burke.)

Dora Williams Dabney (right) is pictured here with her daughter Josephine Dabney Welch and Billy Williams (c. 1951). Born Theodora Williams, Dora was one of twins among 15 children born to Hill and Emma Williams. She was born on September 5, 1901, in the Milridge area in Conyers, Georgia. During her youth, Dora played the piano. She married Evans Dabney on February 20, 1921, with whom she had four daughters: Josephine, Willie, Johnnie, and Ruby. The family moved to Decatur and lived in the Allen Wilson Terrace Apartments. Dora was very active at the Lily Hill Baptist Church and was a member of the Usher and Mothers Board while working as a store clerk at Archie Clark's Grocery Store and Mossman Grocery Store. (Courtesy of Jakki Burke.)

Jacquelyn Welch (front row, right) grew up with her parents and grandparents in the Allen Wilson Terrace Apartments. A graduate of Beacon Elementary and Trinity High School, she matriculated at Morris Brown College, where she graduated in 1966. A dedicated educator since 1967, she has served as the chairperson of the Department of English at D.M. Therrell High School, and in the tradition of schoolteachers of days gone by, Jacquelyn has inspired, motivated, and propelled students to reach beyond their limitations. (Courtesy of Jakki Burke.)

The Dabney girls, from left to right, are as follows: Josephine Dabney Welch, Dora Williams Dabney, Ruby Dabney Davis, and Johnnie Dabney. (Courtesy of Jakki Burke.)

In Greensboro, Georgia, a small hamlet some 75 miles outside of Atlanta, farmer Hollie Brown and his wife, Mary, nurtured a future mayor, their daughter Elizabeth Brown. Attending Greensboro Colored High School, Elizabeth had to walk 4 miles to school while watching white kids ride buses and use new textbooks. Her high school principal was Dr. Horace Tate, who would serve as the state senator from southwest Atlanta during the late 1960s. In 1949, Elizabeth Brown moved to Decatur when she was 18 years old, where she married and raised her family in the Allen Wilson Terrace Apartments. From the 1960s to the 1990s, through an unyielding and unconquerable desire for change, this onetime farm girl rose up to win a series of integration victories, knocking down racial barriers and becoming one of Decatur's most prominent citizens.

In 1962, she integrated the Decatur Public Library, and subsequently campaigned with the NAACP to register black voters. (Courtesy of Elizabeth Wilson.)

50

Elizabeth Wilson's son Richard Wilson (pictured here) attended Decatur High School, beginning a new era of integration education. He also helped to integrate the school's basketball team in 1966. As a member of the basketball team, coached by Roger Kaiser, Wilson had a rigorous schedule not only on the floor but enduring predominately white crowds at the games. Playing at the school's gym and the Decatur Recreation Center, the team also played such schools as South Cobb, Griffin, Marist, Druid Hills, Clarkston, Gordon, Briarcliff, Towers, North Springs, S.W. DeKalb, and Avondale. The team record for that historic first year was 12 and 8. Richard's mother supported him in all his games. (Courtesy of Elizabeth Wilson.)

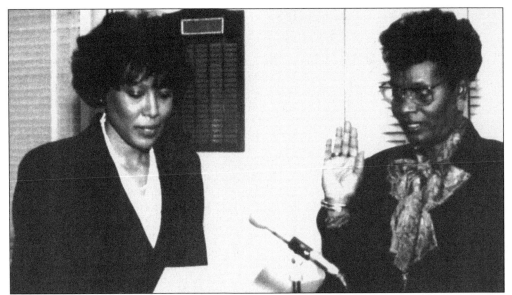

Mrs. Wilson became a state and national PTA officer, and in 1969 organized the Beacon Hill Clinic (which closed in 1974) before co-founding the Oakhurst Community Health Center in 1981 on the site of the old Scottish Rite Hospital to provide medical assistance for DeKalb County's poor residents. Three years later she was elected as the city commissioner of Decatur and was the first African-American person to hold this position, serving a growing black community, which was over 41 percent of the 19,000 population.

In 1993, Elizabeth Wilson's unyielding and unconquerable determination to change the "Old Decatur" won her the mayoral election, making her the first African American and the first female mayor of the city of Decatur. She is pictured here being sworn in by Judge Linda Hunter in 1993. (Courtesy of Elizabeth Wilson.)

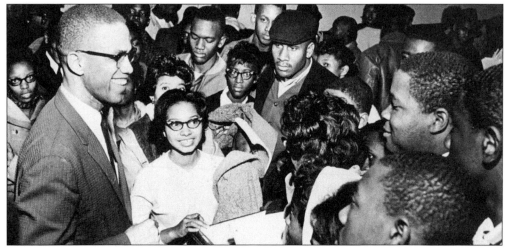

Before Clarence Cooper, regarded by many as a trailblazer for African Americans in the legal and judicial professions, became a lawyer and later a judge, many family and friends knew him as "Coop." Born on May 5, 1942, in Decatur, the son of a domestic worker and truck driver, this onetime resident of the Allen Wilson Terrace apartments went on to become a federal judge. He moved from the "projects" to the Edgewood community when he was ten because his parents made too much money and so were forced to leave the place where he was born.

After graduating from Trinity High School, Cooper attended Clark College (now Clark Atlanta University) and graduated in 1964 with a degree in political science and history. While at Clark, he had an opportunity to see and hear Malcolm X (seen here at left), who visited the campus in 1964. He entered Howard University School of Law, but later transferred to Emory University School of Law, where he graduated in 1967. He was one of the first African Americans to do so. (Courtesy of Skip Mason's Archives.)

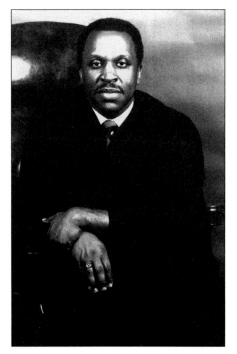

After passing the Georgia Bar Exam, Cooper was hired by the Atlanta Legal Aid Society. In 1968, he became the first African-American assistant district attorney for Fulton County. In 1993, Judge Cooper continued breaking racial barriers by becoming the first African American to win a seat on the Fulton County Superior Court since Reconstruction. In that same year, President Bill Clinton appointed him to the Northern District Court of Georgia—again the first of his race to be so named.

Despite all of his major achievements, Judge Cooper is most famous for having presided over the Wayne Williams murder trial. International press coverage of the trial elevated him to celebrity status, dubbing him the "Wayne Williams judge."

Judge Cooper insists that hard work, education, and love from a closely-knit family can lead any poor child out of the ghetto. His own love for his race made him aspire to become a federal judge, and so give African Americans a chance at justice. (Courtesy of Clarence Cooper.)

Two
Churches in Decatur and DeKalb County

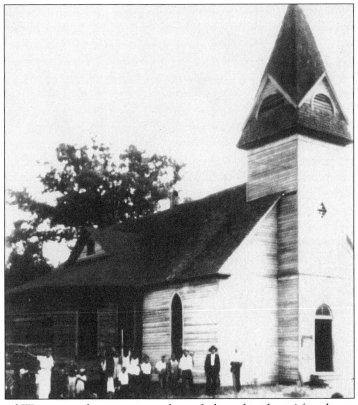

Prior to the Civil War, many slaves were members of white churches. After the war, encouraged by the desire for independence, African Americans withdrew from white churches and began forming their own. In 1867, during the early stages of the Reconstruction period, the foundation for the Antioch African Methodist Episcopal Church was established by freed slaves. Though unnamed, worship services began in the home of Sister Lou Bratcher on Electric Avenue. Members would meet in her home every first and third Sunday. The following ministers were placed in charged: Jethro Brooks, Henry Anderson, William Howard, Van Ross, and James Jackson. The first pastor to serve Antioch was Rev. William Stencil, who helped to raise over $400 to purchase land. Services were held outside under the trees. In 1874, the congregation built a one-room structure adjacent to the parsonage on Trinity Street, where DeKalb County's Callaway Building is now situated. The church grew to the extent that tickets had to be given to members in order that they would be able to get seats. Picture here is the Antioch A.M.E. Church c. 1930. (Courtesy of Sylvia Kemp Clark.)

Many outstanding pastors served the church, including Rev. Thomas Jefferson Flanigan, a graduate of Atlanta University, prolific writer, and poet. As the congregation continued to grow, the church changed locations. From 1933 until 1965, it was located on Marshall and Cooper Streets. Mrs. Lena Harper Kemp wrote the rich history of the church. The old church bell was cast in Cincinatti in 1889. When the church relocated, the bell was preserved and still stands as a symbol of faith and independence for the African-American community. (Courtesy of Digging It Up Archives.)

This is the Antioch Church Choir, c. 1940. On the back row, left is Lawrence Mann, a musician who taught piano lessons in the homes of several children in the community. (Courtesy of Sylvia Kemp Clark.)

Helen Grace Starr Smith (seen here) was the musician for the church choir at Antioch. The Starr family lived in what Helen called "the bottom," an area at the foot of the hill near the old Crematorium. Helen began playing piano at Sunday school at Antioch A.M.E. when she was ten. She was the daughter of Samuel and Cora Beatrice Starr and was born in Covington, Georgia. Her father, Samuel Starr, was a painter, and her mother, Cora Starr, made sure that she and her brother Walter were involved in extracurricular activities. With the money Cora earned doing laundry for white families that lived near Trinity and Sycamore Streets, she was able to give her children their first piano lesson from Lawrence Mann. The kids would go "across Decatur" to pick up the laundry. When they arrived in Decatur, they lived in a duplex apartment and later rented a house from two Jewish men, known as Mr. Rosenbaum and Mr. Rich on Atlanta Avenue, where they stayed until they moved to a newer home off of Atlanta Avenue. Mrs. Starr recalled that she and other children would play in the "Branch," a stream of running waters which might have come from a sewer. After attending beauty college in the 1940s in Atlanta, Mrs. Starr opened the Starr and Fisher Beauty Shop on Atlanta Avenue, where it operated until the 1970s.

Helen Starr, like so many others in Decatur, rode the streetcar to Atlanta to attend Atlanta University Laboratory High School and Spelman College, where she graduated in 1942 with a degree in home economics. She later enrolled in the Women's Army Corp. (WAC), before moving to New York earning a master's degree in early childhood education at New York University. Returning to Atlanta, Mrs. Starr Smith taught at Lynwood Park. She retired from the DeKalb Public School System after 30 years of service. (Courtesy of Sylvia Ann Kemp Clark.)

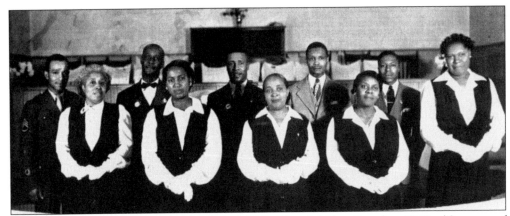

Pictured here are members of the Antioch A.M.E. Church Usher Board, *c.* 1940s. (Courtesy of Sylvia Kemp Clark.)

The Mt. Zion African Methodist Episcopal Church was established in 1870 and was located near the Lawrenceville Highway. Originally named Rocky Knoll A.M.E. Church, its founding pastor was Rev. Granison Daniel. Under the leadership of its second pastor, Reverend Merclain, the church relocated to an area on Lavista Road and held services out of an old boxcar. Judson Stokes of the Decatur A.M.E. Church provided some land, and the present building was erected. The name was changed to Mt. Zion, which was also the name of the community. Annual camp meetings were held and many preachers have served the church over the last century. In 1993, the church became a "Station" church, a traditional term meaning that the church would have full-time operation and services held on each Sunday.

Mother Hannah Burnett, a community organizer, founded Lilly Hill Baptist Church in 1913. Burnett (pictured with her husband, John) was born in Pike County. She married John Burnett, and they became the parents of 11 children. She died on March 26, 1945. The church bears the Hannah Burnett Willing Workers Club. (Courtesy of Jakki Burke.)

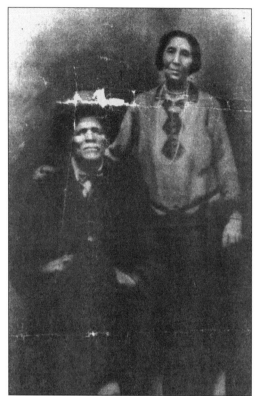

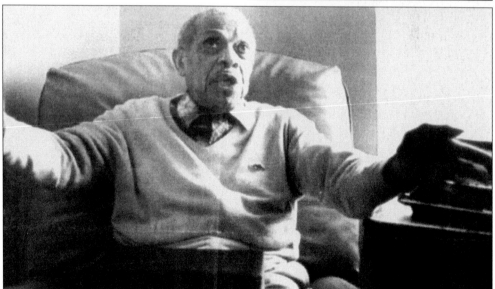

Rev. Roy Moss was born in Decatur in 1900. At the age of 22, he began working for the City as part of a street construction crew. After the completion of the new Decatur City Hall, Moss became the building's first full-time janitor, where he worked for 30 years. He then found employment at the Belk-Gallant Department Store (located next door to City Hall), where he worked another 16 years. However, he is better known for his 29-year pastorate of the Mt. Zion Baptist Church.

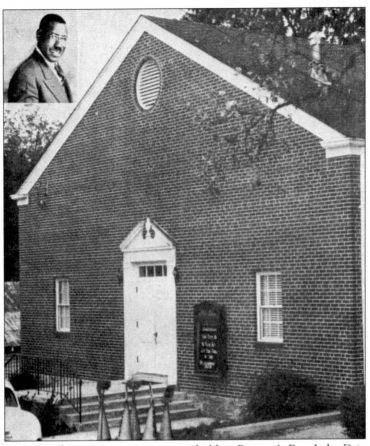

As Lilly Hill grew, weekly prayer meetings were held in Burnett's East Lake Drive home. On prayer meeting evenings, all the beds were taken down and moved to another part of the house. During one of these meetings, two of her sons, Ed and Clem, joined the meeting and were later baptized. The first teacher of the church was Roberta Watkins. As the group grew into a large congregation, they moved to a tent on Electric Avenue at Robin Street. It was during their tent meetings that Felix Banks named the church Lilly Hill. Deacon Henry Grier of the Thankful Baptist Church assisted in ordaining some of the men as deacons. The church was forced to move three blocks away on Robin during the construction of the Allen Wilson Terrace Apartments. Serving as the first minister was Rev. Herschel Scruggs. Other members who served included Reverend Watson, Reverend Jackson, Rev. J.H. Barnes, Rev. T.T. Balls, Rev. David Dixon, and Rev. G.B. Marignay.

Later, Lilly Hill Baptist Church moved to the site of "Spring House" near Atlanta Avenue and Water Street, where it is presently located. Lilly Hill Baptist Church continues to contribute to the community and provide outstanding leadership.

Rev. G.B. Marignay (inset) was known as the "Dean" of African-American pastors in Decatur. Originally from South Carolina, he moved to Georgia in 1923 and resided in Scottdale. For 14 years, he served as church deacon and chairman of the board at Lilly Hill Baptist Church. In 1943, he assumed the duties of pastor in addition to being moderator of the Hopwell Association of the National Baptist Convention and partner in the Decatur Cooperative Ministry.

In 1984, Rev. G.B. Marignay retired after 41 years of service. His tenure at Lilly Hill Baptist Church was one of the longest of any African-American minister. (Reprinted from Souvenir Booklet; courtesy of Sylvia Kemp Clark.)

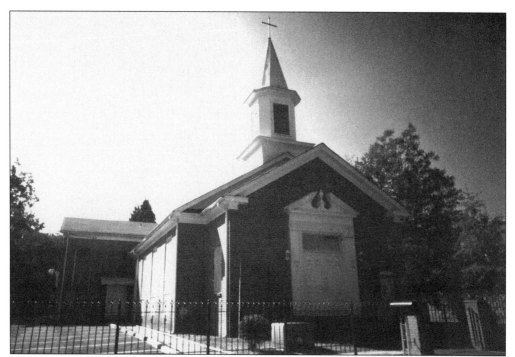

This is the former Trinity Presbyterian Church, located on Robin Street.

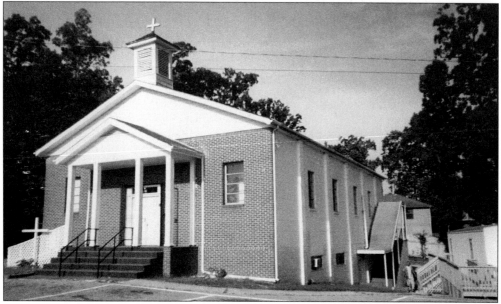

The exact date of the founding of the Poplar Springs Baptist Church on River Road in Ellenwood is unknown, but it was established in the 1800s. The structure seen here was rebuilt in 1963. Adjacent to the church is the burial ground of many of its former members, including the Barnes, Rice, Moore, Guthrie, Strickland, and Goodson families. One of the oldest markers belonged to Clara Smith, who died in 1907, though there are probably unmarked graves dating back to the 1800s. Another church located off of River Road is the New Jerusalem A.M.E. Church on the Bouldercrest and River Road. (Courtesy of the author.)

The headstone of Henry McGinnes, who died January 7, 1913, is one of hundreds of members' graves of the County Line Methodist Church, organized in 1869 in Ellenwood. Located on Old River Road, near the County Line park, in 1956 the current structure was rebuilt under the leadership of noted presiding Bishop J.W.E. Bowen, with Grand Master Clem Davenport laying the cornerstone. The trustees of the church were some of the leading citizens of the Ellenwood area and included Willie Frank Langston, L.J. Shaw, Arthur Langford, P.P. Jones, Edward Langston, Cleo Clark, Henry Langston, Charlie Clark, Prince Clark, Grover Robinson, Lorenzo Clark, Miles Robinson, Samuel Jones, Lincoln Jones, and Ralph Jones. (Courtesy of the author.)

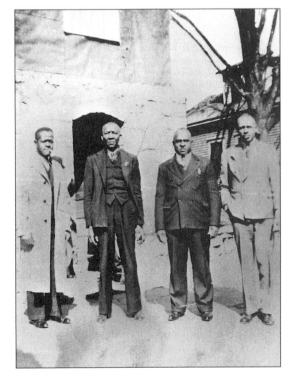

Deacons of any Baptist church were unelected leaders of the community. The Thankful Baptist Church deacons were stalwarts of the Beacon community. Deacons, from left to right, are as follows: James Bussey, Jake Sims, Arthur Kirkland, and Claude Copton, c. 1940s. (Courtesy of the DeKalb Historical Society.)

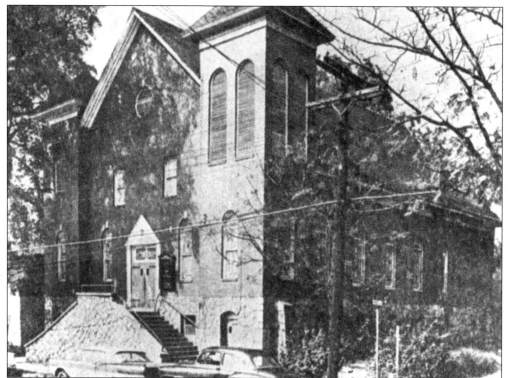

Thankful Baptist Church, established in 1882 by a group of newly freed slaves who migrated from Augusta, Georgia, is the oldest African-American church in the city of Decatur. Cornfields once surrounded the site. It was named for the Thankful Baptist Church in Augusta. In the beginning, the membership met in a log house owned by the Reverend Frank Paschal and his family and later in the schoolhouse of Rev. Lewis Thornton. By WW I, the church began a building campaign. A pair of mules tore down the old church structure, and work was begun on a basement with additional parts being added to it. Baptisms were held at Peavine Creek, which was located near the site of the old church building. Thankful was a member of the Hopewell Association, founded in Gwinnett County, and supported the efforts of Bryant Baptist Institute, founded by Sylvia Jenkins Bryant, wife of Rev. Peters James Bryant, pastor of Wheat Street Baptist Church.

During WW II, the congregation raised $4,000 to build a rock church, which was located on Atlanta Avenue. Thankful was the cornerstone of the black community in Decatur. Located in the heart of the Beacon residential and business community, Thankful was used for many public programs, gospel, and musical concerts. The church had a long and rich history. Thankful offered the Baptist Young People's Union (BYPU), night services, Sunday school, and morning services. Many young folks in the church courted during BYPU meetings.

Thankful was making plans for expansion when in 1970, a fire broke out and destroyed the building. Rumors sparked that it was burned purposely to clear out land for the mass urban renewal. The following year, on July 4, 1971, Rev. Leon Tucker led the congregation from prayer at the ashes of the old site to the Pattillo Memorial United Methodist Church building on West College Avenue, which was purchased to be the new home of Thankful Baptist Church.

Over the years, Thankful Baptist Church has produced many preachers, educators, and community leaders who have been excellent role models for the children of the community. It is an example of the important role that the church has played in the uplifting of the African-American community. (Courtesy of the DeKalb Historical Society.)

In 1955, the Decatur Interdominational Ministerial Alliance was organized.

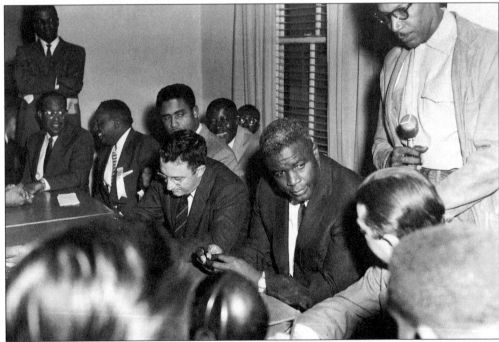

One of the biggest events to occur in Decatur was the appearance of legendary baseball player Jackie Robinson, who integrated professional baseball in 1947. In the early 1960s, Robinson came to Thankful Baptist Church on behalf of the NAACP, of which he was a vocal component. The church was unable to accommodate the hundreds who lined the streets to get a glimpse at this sports hero. Robinson remarked about the episode involving Dr. King's arrest in DeKalb County. When Dr. King was arrested and sentenced to four months in jail to be served at hard labor on a road gang by a hostile judge in DeKalb County, Harry Belafonte urged Jackie Robinson to appeal to Nixon campaign leaders for a direct show of support for Dr. King. Robinson pleaded with William Safire, saying that Nixon had to intervene. He offered to give Nixon the number. After a meeting with him, Nixon said that calling King would be grandstanding. Robinson blurted out that "Nixon does not deserve to win." And he did not. (Courtesy of T.M. Pennington/Skip Mason Archives.)

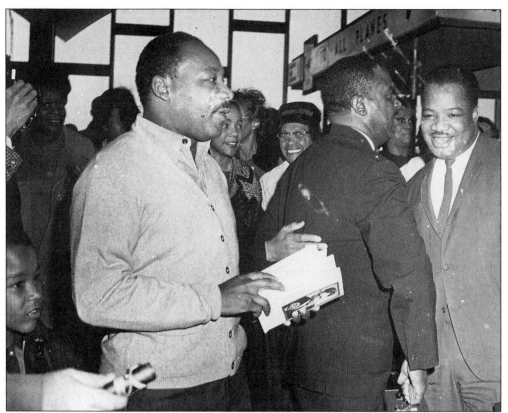

On May 4, 1960, after dining out, Dr. Martin Luther King Jr. (left) drove his wife, Coretta, and eminent writer Lillian Smith to Emory University Hospital, where Ms. Smith was undergoing treatment. A DeKalb County police officer pulled them over, because of the interracial mix of the group. Dr. King, due to a tremendously busy schedule, had not renewed his driver's permit and was issued a citation. When he went to court, the judge fined him $25 and placed him on probation for one year.

Later that year on October 19, at the request of student protesters, Dr. King participated in a sit-in at Rich's Department Store in Atlanta, Georgia. They were all arrested, charged with trespassing, and taken to jail. The following day, charges were dropped and everyone, with the exception of Dr. King, was released. Authorities in DeKalb County demanded custody of him, insisting that he had violated probation.

The following Tuesday, at a hearing in the DeKalb County Court House, Dr. King was sentenced by Judge J. Oscar Mitchell to six months in the Reidsville State Penitentiary. The incarceration of such a renowned civil rights leader sparked immediate reaction on national and international levels alike. Under pressure from Senator Kennedy, Judge Mitchell released King on bail.

During the same year of King's arrest, 50,000 people took to the streets to protest racial segregation. As a result, department stores in city after city either changed their policies or went out of business. (Courtesy of Skip Mason's Archives.)

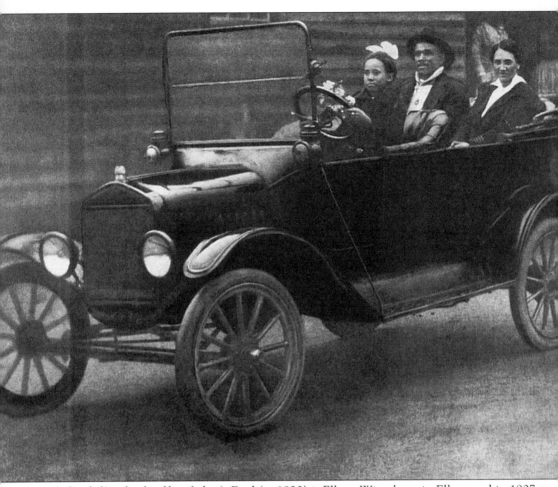

Behind the wheels of her father's Ford (c. 1920) is Ellena Wise, born in Ellenwood in 1907 to John and Eula Fletcher Wise. John Wise, perhaps Ellenwood's most successful African-American cotton farmer, was born in Butts County. He came to South DeKalb as a young boy and over the years acquired property throughout the area, including the South River area. His daughter remembered that he "ran a 10-horse" farm, which was a large farm. The Wise family resided on what is Amsler Road off of Flakes Mill Road, which was then an unnamed dirt road. While teaching a young man to rabbit hunt, John Wise's arm was accidentally shot off and was attended to by Dr. Sprayberry, a white doctor in the Ellenwood area. Wise's Ford was specially equipped with a foot pedal to change gears. Ellena married Samuel Jones around 1929, and they were the parents of six children. Today, at the age of 91, Ellena still lives on an acre of the over 37 acres of property that her father owned in Ellenwood. (Courtesy of Ellena Wise Jones.)

Three
ELLENWOOD

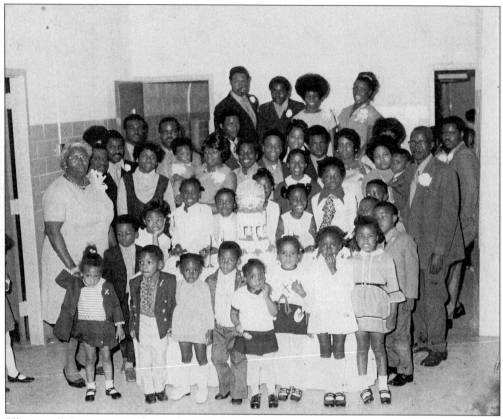

Ellenwood, Georgia, now located in south DeKalb County, was in Clayton County before the county boundaries changed. The area was known as County Line, which was also the name of the road before it was changed to River Road. It was the home of numerous African-American families, many of whom owned large amounts of land in and around the River Road area. Today, much of this land has been acquired by developers, who have built sprawling subdivisions.

Pictured here are three generations of the Cleo and Lillia Clark family, who are shown celebrating their 50th wedding anniversary surrounded by their children, grandchildren, and great-grandchildren. Cleo Solomon Clark (far right, with glasses) was born January 21, 1901, to Lewis and Liza Clark in DeKalb County. He was an active member of the County Line Methodist Church and the Prince Hall Order of Free and Accepted Masons. In 1921, he married Lillia Mae McGinnis (far right), and they were the parents of 13 children. At the time of his death on February 18, 1984, Cleo Clark had 47 grandchildren, 75 great-grandchildren, and 3 great-great-grandchildren. (Courtesy of Tom and Dora Johnson/Cynthia Jones.)

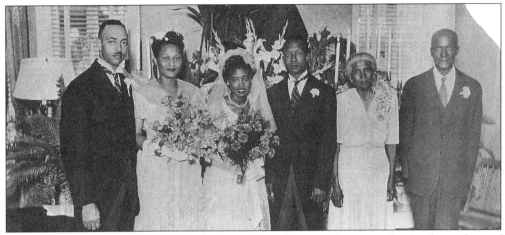

This is the beautiful wedding of Susie Jones and Jerry Drayton. Susie was the daughter of one of the pioneer leaders of Ellenwood and South DeKalb, Pleas P. Jones. Seen here c. 1946, from left to right, are as follows: Rev. Dr. Thomas Kilgore, Ms. Lucille Alston (maid of honor), Susie Jones, Jerry Drayton, Mrs. Bertha Freeman Jones, and Mr. Pleas Jones. Pleas and Bertha Jones were the parents of six children: Samuel, Ralph, Henry, Lincoln, Major, Mary, and Susie. Pleas Jones, born in Conyers, Georgia, was working in Rome, Georgia, as a schoolteacher when he met his wife. They moved to Atlanta. For a brief period, he and his brother T.B. Jones operated a restaurant on Hunter Street. After that failed during the Depression, he moved to Ellenwood and began farming. Being highly efficient in mathematics, Jones would often help cotton farmers (both white and black) to calculate their earnings. (Courtesy of Susie Drayton.)

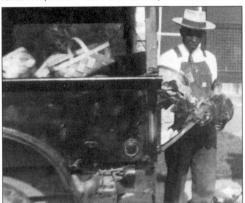

Left: Henry Lincoln Jones, a son of Pleas Jones, attended Tuskegee for a year and studied agriculture. He developed a cotton crop one year that produced $10,000. With his building skills, he started a construction company in Ellenwood, which built homes, apartments, and churches. Lincoln Jones was also one of the first African Americans to serve on the DeKalb County Jury. (Courtesy of Lincoln Jones.)

Right: One of the true pioneers of Ellenwood, Tom Johnson is seen here with his wife, the former Sarah Arizona Washington, who was 12 years old when he married her in 1908. In 1886, Tom Johnson fled DeKalb County to escape a lynch mob and ended up in Dallas, Georgia, where he worked for several months. A hard worker all his life, Johnson labored as a farmer, a construction worker, a plumber, a bridge builder, and a dairyman— to name only a few. Tom and Sarah Johnson were married for over 70 years and were the parents of seven children. He died on June 14, 1984, and was buried at the family cemetery, Old Hopewell Cemetery, located in Conley, Georgia, near the Cedar Grove area. (Courtesy of Tom and Dora Johnson.)

Four

THE JEANES SCHOOLS AND EDUCATION

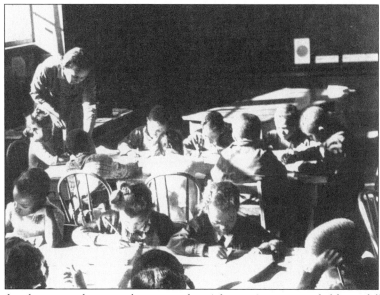

Efforts to develop an educational system for African-American children following the emancipation of slaves began as early as 1865. By an act of Congress, the Freedman's Bureau was created. With the help of philanthropic organizations, missionary societies, and many dedicated African-American educators, the bureau provided the framework for the development and expansion of African-American education. As schools were developed in Atlanta, those able to obtain a private education at Spelman or Morris Brown, and later, Morehouse Academy, made the journey to Atlanta to attend the schools.

African-American schools were often housed in one-room, poorly constructed shacks, or in temporary church quarters. Having such items as proper roofing, a potable well, a sanitary outhouse, and adequate books were considered major accomplishments. It wasn't until 1907, when a wealthy Quaker woman named Anna T. Jeanes established funds to improve African-American schools, that these rudimentary conditions began to change.

In 1923, there were 12 one-teacher schools and 3 elementary/secondary combination schools in DeKalb County. A mission of the Jeanes Supervision Program was to merge the one-teacher schools into larger, more adequately equipped schools. In 1948, the first consolidation took place, eliminating three of the one-teacher schools: Redan, Miller Grove, and Flat Rock. In their place, Bruce Street School was created in south DeKalb County. Following this consolidation in 1949, the other one-teacher schools were consolidated into five additional schools: County Line, Hamilton High School, Robert Shaw, Lynwood Park School, and Victoria Simmons.

With the assistance of energetic and loyal teachers trained to become Jeanes supervisors such as Mrs. Marie Foster (left), who served from 1924 to 1926, and Mattie Braxton (right), who served from 1943 to 1944, improvements in the areas of teaching, curriculum, and building aesthetics took place in African-American schools. After the Supreme Court school desegregation decision of 1954, 17 schools were combined into six modern buildings. They were used until the public school system in DeKalb County became desegregated. Prior to the 1954 court case decision, the Jeanes Supervisor Program played a vital role in the development of African-American education in DeKalb County. Other Jeanes supervisors included Mrs. Clyde Adams, 1923–24 and 1928–38; Miss Ella Tackwood, 1938–1940; Miss Frankie Golden, 1940–1941; and Mrs. Narvie Jordan Harris. (Courtesy of Narvie Jordan Harris.)

"Our school house was an old fashioned one room building with a stack chimney that you could lay a piece of four foot wood in, but we did not have the wood We would go and get armfuls of sticks and brush to warm by We could see out the top, sides or floor without leaving our benches or boxes that we sat on. We had plenty of ventilation."
—D.G. Ebster, 1926

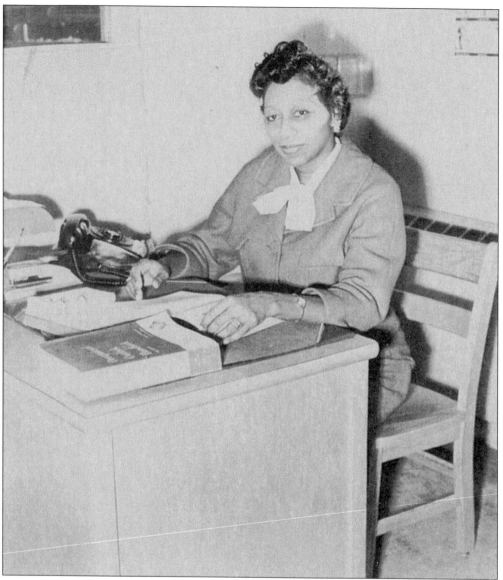

The sixth and final Jeanes supervisor was Narvie Jordan Harris. She was born in Riceville, Georgia, but moved to Atlanta during her childhood and attended public schools in Atlanta. Her father, James E. Jordan, was an established businessman on Auburn Avenue. He owned a tailoring shop, hair chemical company Hy-Beaute, and a photography and cinematography studio. The Jordan family resided on Lena Street. Narvie went on to graduate from Clark College. Because of her excellent grades, she was selected to be a Jeanes supervisor in DeKalb County in 1944. She completed her master's degree in education from Atlanta University. During 1943 and 1944, Mrs. Harris worked at Atlanta University as one of the first teachers chosen to study supervision through a grant offered by the Georgia State Department of Education. (Courtesy of Narvie Jordan Harris.)

In 1945, Narvie Harris helped to establish the DeKalb County PTA Council, which was organized for the purpose of parent education and leadership. By 1949, she had helped to consolidate nine of the small schools and saw Avondale and Bruce Street High accredited. Enrollment and faculty in the schools grew steadily from 1944 to 1972.

Mrs. Harris retired in 1985. Her impact on African-American education in DeKalb County was far reaching. Active with the State Teachers Association, DeKalb County Retired Teachers Association, and her beloved Wheat Street Church, Mrs. Harris has single-handedly recorded much of the African-American educational history of DeKalb County. With a brownie camera, she traveled from school to school documenting history. This report of the "colored schools in DeKalb County for 1949–1950" has been a major resource for providing information about the schools of the county. In April 1985, Mrs. Harris was named honorary associate superintendent of the DeKalb Board of Education. (Courtesy of Narvie Jordan Harris.)

Bus service for African Americans in DeKalb County began in 1948. The bus was used to pick up children from Flat Rock, Miller Grove, and Redan areas to transport them to Bruce Street. (Courtesy of Narvie Jordan Harris.)

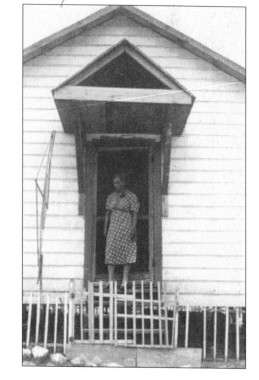

Other one-teacher schools located in DeKalb County from the 1920s to the 1940s included the Piney Grove School, near South Hairston Road and Covington Highway, and the Bethlehem School (seen here), located in the Columbia Drive area. The principal of Bethlehem was Mrs. Melvina Hawkins. (Courtesy of Narvie Jordan Harris.)

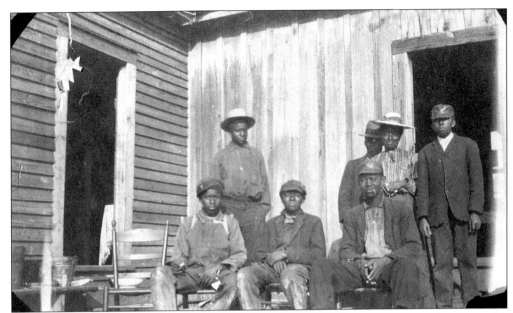

Located between Covington Highway and Snapfinger Woods Drive was an area known as the "Miller Grove" community. A public school for African-American children existed between the years of 1919 and 1947. One of its early principals was Mrs. M.M. Rainwater. In the 1940s, Mrs. Gwendolyn Ealey was the principal. This school was named in honor of the Miller family who once owned a large tract of land in the area. The Miller Grove Baptist Church served as the original school site. Miller Grove School no longer exists. Unfortunately, no historical data of African-American schools in DeKalb County currently exists in the files of primary and secondary schools in the county. (Courtesy of Skip Mason's Archives.)

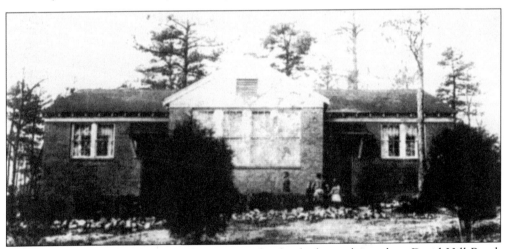

This image is of the Mt. Moriah Elementary School, which was located on Druid Hill Road, near Briarcliff High School. It was a two-room brick building furnished with electric ranges, tables, and cabinets. Students pose near the school in 1949, around the time the school was consolidated with the Mount Moriah school. A school bus helped to transport these students. Irma Bowens was one of its principals. In 1949, Mt. Zion, on Lavista, consolidated with Mt. Moriah (also spelied "Mariah"), and the school bus transported the children to Mt. Moriah. A fire later destroyed the school. (Courtesy of Narvie Jordan Harris.)

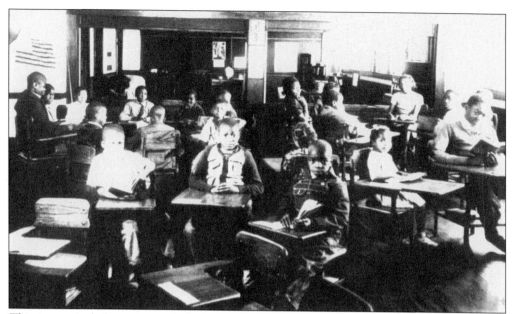

This is a typical classroom scene from one of the many Jeanes Schools in the DeKalb County area, c. 1940.

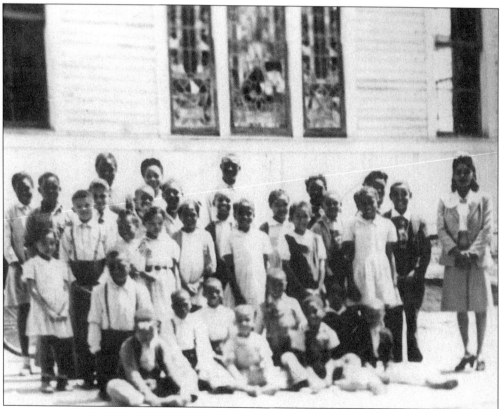

Mrs. Fannie Hardy is seen here with her schoolchildren at Flat Rock, c. 1944. (Courtesy of Narvie Jordan Harris.)

The Hopewell School and Church was located on Bouldercrest Road near the Cedar Grove and Conley area of South DeKalb. In 1944, Mrs. Fannie Eberhart served as one of the principals for the school. (Courtesy of Narvie Jordan Harris.)

Five
AVONDALE

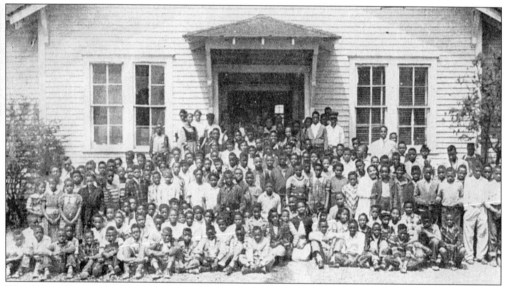

The City of Avondale Estates, Georgia, was incorporated in 1926 and operated with a board of commissioners, a mayor, and a city manager. Located east of Decatur on Covington Road, it was one of DeKalb's most beautiful areas. The village also contained a segregated movie theater which served African Americans in the surrounding areas. One Scottdale resident recalled climbing the side steps of the Avondale Theater to see *Gone With the Wind*.

Education in the Avondale area was greatly enhanced through generous financial contributions. Between 1912 and 1932, philanthropist Julius Rosenwald helped to build nearly 5,000 schools for African Americans in 15 Southern states. Robert Shaw, a leader in the African-American community, donated land for the construction of the Avondale Colored Elementary and High School. Built in 1924 in the Scottdale community, it became the first Rosenwald School in DeKalb County and served both the primary and secondary educational needs of the students. Located 2 miles north of Decatur, the school (pictured here) consisted of a main building, two barracks, and a home economics room. (Courtesy of Narvie Jordan Harris.)

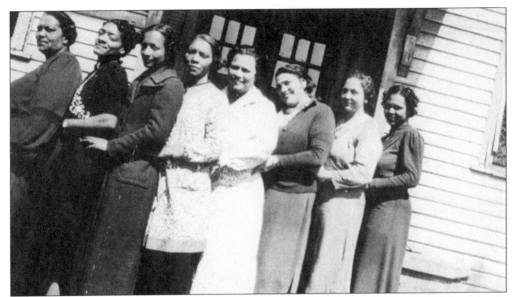

Pictured here are members of the Avondale Colored School faculty *c.* 1930. Mrs. Maude Hamilton (seventh from right) served as the principal. Other faculty members who would later join the staff included Ann Weathers (librarian), M.L. Burse (music), E.C. Riggins, W.M. Hatton, G.B. Jones (athletics), G. Stovall (music), C. Lester (athletics), P.B. Allen (art), H.M. Brewster (music), and F.C. Smith (dramatics). From 1940 to1942, major improvements were made, including running water, a science laboratory, a new piano, a library, a telephone, standardized testing, permanent records, and an addition of audio visual aids. (Courtesy of Narvie Jordan Harris.)

In March 1949, the Adult Academic program was introduced to the Avondale community. It consisted of 35 men representing three counties. Mrs. Fannie M. Eberhart was the instructor. John Shanks, pioneer activist, served as class president, and the group gave public programs at Antioch A.M.E. Church. (Courtesy of Narvie Jordan Harris.)

Pictured here is the Avondale School dramatics class, *c.* 1949.

In 1949, several schools offered veterans' classes for men who had fought during WW II. Pictured here is the class at County Line.

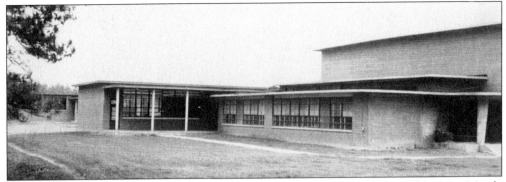

In 1955, Avondale Elementary School became Hamilton High School, named for Mrs. Maude Hamilton, one of its first principals. It also became DeKalb County's primary African-American high school outside of Trinity High School in Decatur. Avondale Elementary/Hamilton High School served as a positive institution of learning for the African-American youth of DeKalb County and the Scottdale community.

Mrs. E.C. Riggins was the first principal of the Robert Shaw Elementary School.

Pictured here are Avondale School bus drivers, *c.* 1955.

Principal William Hatton is seen here in front of Hamilton High School, *c.* 1960s.

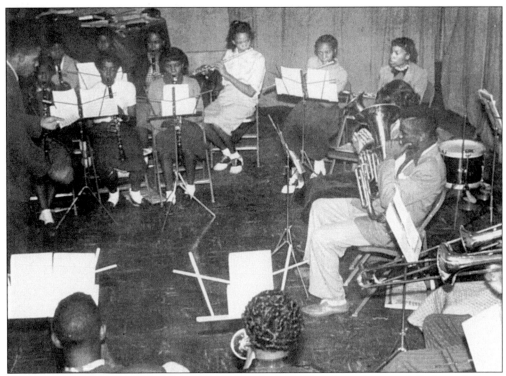

William Braynon was the band director at Avondale, Hamilton, Lynwood Park, and Bruce High Schools. He has had a rich career as a musician, playing in local bands and performing in nightclubs throughout Atlanta and Decatur.

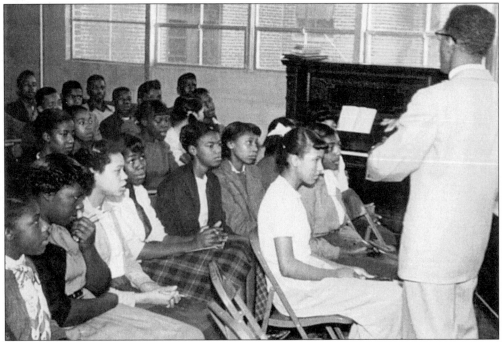

Mr. J. Wills directs the Hamilton High School Chorus, *c.* 1950s.

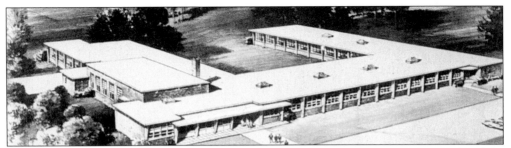

The Robert Shaw School reopened as an elementary school in 1998 after being closed for 30 years.

The Hamilton High School girls varsity basketball team (*c.* 1966), from left to right, are as follows: (kneeling) Joe Ann Flemister, Cynthia Nelms, La Dema Thomas, Patsy Hambrick, Linda Kennemore, and Laura Young; (standing) Mrs. I.D. Holston, Sandra Armour, Jeanette Wade, Shelia Johnson, Shirley Clark, Iris Graham, Cherry Bigby, Jo Ann Stone, and Mary Lundy.

The original house of the Porter Plantation, once owned by Joseph Walker, was burned by Sherman's troops during the Civil War. The land started at Covington Highway and extended into the Indian Creek area. In 1903, the original house and 50 acres of land were sold to Frank Henry Porter, an African-American man who traveled several miles on a mule-drawn wagon filled with furniture, chickens, and farm tools.

Frank Henry Porter was one of the first African-American landowners in the county. The farm, which is still surrounded by mulberry trees, was the last site in Georgia where silkworms were raised commercially. Porter bought the property for $1,000, an amount considered extravagant during those days. Members of the family included Mr. and Mrs. Frank Porter, Frances Porter Evans, Gertrude, and Mattie Lou.

Today, where Porter Road branches off from Kensington Road, all that remains of the original Porter Plantation is a wing, which now houses a DeKalb County government facility and the Porter family cemetery.

According to oral history, Mount Pleasant Baptist Church (seen here) was organized when slave-owner Joseph Walker witnessed his slaves engaging in worship and misunderstood their religious expression. He deemed the ceremony "half-heathenish," an attempt by the slaves to return to their African roots. Subsequently, he organized an African-American church. Believing there was no African-American man who could assume the leadership of the church, Joseph Walker became the pastor. Today, Mt. Pleasant still stands at its original site, off Covington Highway on Porter Road. The church claims to be the oldest African-American church in DeKalb County. (Courtesy of Skip Mason's Archives.)

Six

CHAMBLEE, CAMP GORDON, AND DUNWOODY

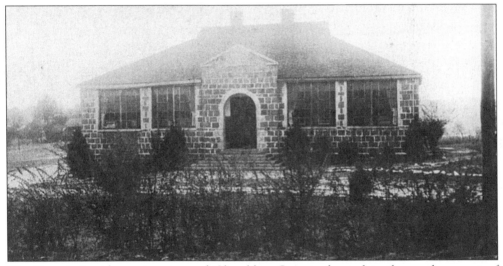

The Georgia Legislature incorporated Chamblee, Georgia, located in the northern part of DeKalb County, as a town in 1908. The original settlement started near the Prospect Methodist Episcopal Church South and had been initially occupied by Creek Indians. It was established in 1828. For this reason, Chamblee is considered one of the oldest communities in north DeKalb. According to local folklore, the town of Chamblee was named by the United States Post Office. Initially, a group of settlers requested that the new post office be named Roswell Junction, for the railroad line to Roswell that branched off at the town. The post office objected to this name because it was too similar to an existing post office in the town of Roswell. A second name was submitted by the townspeople, which also conflicted with the name of another post office. Finally, the U.S. Postal Service asked a name be picked at random from the list of petitioners. Permission was granted, and the name of an African-American railroad worker, Chamblee, was chosen.

Dunwoody was named for John Dunwody (the second "o" was added later), who came from Darien to Roswell. Dunwody accumulated great wealth as a planter in the coastal Georgia town. Major Dunwody applied for and was granted the first post office designation in 1881. After a railroad was built in the 1880s, Dunwoody returned to its prewar occupation of manufacturing. The town relied heavily on the labor of African Americans residing in and near the area. On the present site of Oglethorpe University, a small cotton mill operated. Dunwoody remained a small rural agricultural community until WW I. (Courtesy of Narvie Jordan Harris.)

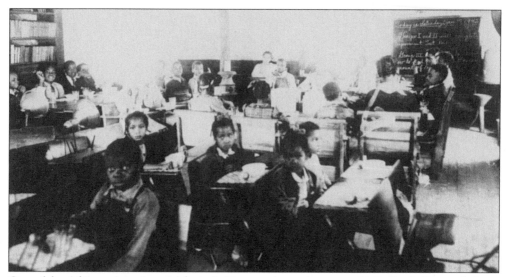

One of the African-American enclaves in Dunwoody was known as Little Rock. Pictured above is a classroom scene from the Chamblee Elementary School c. 1940. Mrs. Lottie Jones was a teacher, and L.A. Robinson served as principal. (Courtesy of Narvie Jordan Harris.)

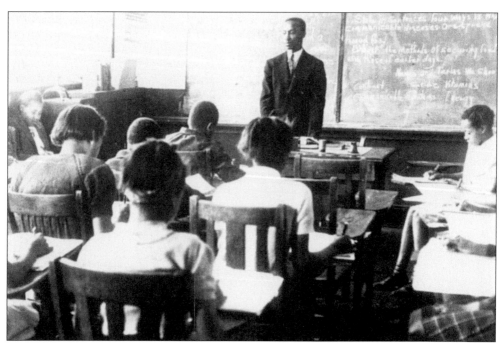

Mr. William Hatton, who would later serve as principal of Hamilton High School, was one of Chamblee's early teachers. (Courtesy of Narvie Jordan Harris.)

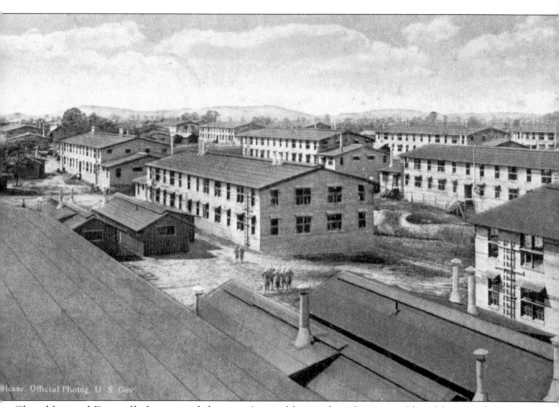

Hesse. Official Photog. U. S. Gov.

Chamblee and Doraville have a rich history. Legend has it that the name Chamblee may have been a Native American word "Shambonee," which means "built like a bear." In the 1820s, when white settlers arrived to claim 202.5 plots of land given by the federal government, Creek and Cherokee Indians were still living in the area. The City was incorporated in 1908. Chamblee remained a dairy farming community until General Motors opened its Doraville plant in 1948. Developers later built apartment complexes along Buford Highway. Shown above are partial views of Camp Gordon, which came into existence during WW I. From September 1917 to November 1918, more than 130,000 soldiers and officers were mobilized. The huge infantry training camp, for the famous 82nd Division, covered 2,600 acres of land. It was also an integrated camp. African-American soldiers were quartered there, though separated because of racial laws. Camp Gordon was called upon to accept "Colored" registrants from Georgia because it was a cantonment rather than a camp. (Courtesy of Skip Mason's Archives.)

". . . the greatest work the colored man can do to help his race upward is by, in his own person and through cooperation with his fellows, showing the dignity of service by colored man and colored woman for all our people I congratulate all colored men and women and all their white fellow Americans upon the gallantry and efficiency with which the colored men have behaved at the front, and the efficiency and wish to render service which have been shown by both the colored men and the colored women behind them in this country."
—Theodore Roosevelt, 1918

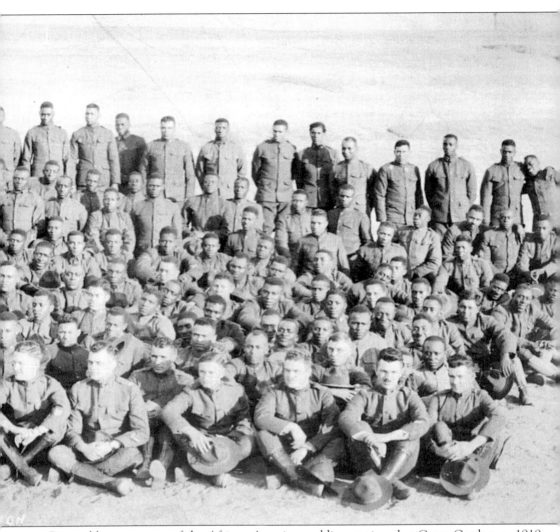

Pictured here are some of the African-American soldiers stationed at Camp Gordon, c. 1919. When the war against Germany was declared April 6, 1917, it was quickly recognized that this was to be a war for all the people of the United States. More than 400,000 black soldiers were called to the war. It was proven at Camp Gordon in DeKalb County that black and white men could be trained together without friction. The first call for "colored" selection came in September 1917, with approximately 9,000 men reporting. It was during WW I that soldier Henry Johnson became the first African American to receive the Croix de Guerre, for killing 4 Germans and wounding 22 with his bolo knife. Emmett J. Scott, former secretary to Booker T. Washington at Tuskegee and special assistant to Secretary of War, the Honorable Newton Baker, compiled an official history of African-American participation in WW I in his book *The American Negro in the World War*. The book documented not only soldiers, but also other war related organizations such as the YMCA, the YWCA, and the War Camp Community Service. (Courtesy of Willis Jones/Digging It Up Archives.)

Located near Camp Gordon was Johnsontown, an African-American settlement situated where Lenox Square shopping mall now sits. Today, the Chamblee/Doraville area is one of the most culturally diversified communities in Georgia, stretching along a 6-mile strip of Buford Highway between North Druid Hills and Gwinnett County.

Seven

CLARKSTON
AND DORAVILLE

The city of Clarkston, in DeKalb County, was named for Col. W.W. Clark, director of the Georgia Railroad and Banking company. Colonel Clark also had a law practice in Covington, Georgia. Clarkston was incorporated in 1882 and had a small African-American population. The Clarkston Negro Elementary School (seen here) was located in a two-room house, which was later converted into a school building off the Stone Mountain Highway, approximately 3 miles from Scottdale. (Courtesy of Narvie Jordan Harris.)

Doraville, Georgia, was incorporated by an act of the Georgia General Assembly approved on December 15, 1871. It was named for Dora Jack, whose father was an official of the Atlanta and Charlotte Air Line Railway (now a part of the Southern Railway).

Located near the intersection of Interstate 285 and Peachtree Industrial Boulevard is an African-American enclave of Doraville known as "Carver Hills." This was a community with a strong sense of unity and kinship. Many of its residents today are retired. In 1986, the Georgia Supreme Court upheld a lower court's decision blocking the rezoning of a black enclave in Doraville for the construction of a hotel. Fannie Mae Jett, a longtime resident of the community, led the fight against the developer's plan to disrupt the Carver Hills community.

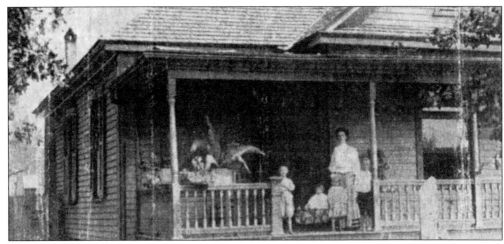

Bordering Moreland Avenue, Memorial Drive, Flatshoals Road, and Glenwood Avenue is the community of East Atlanta. African Americans began moving to this old Civil War battle area in the late 1960s. Located in this community are historic markers citing the events of the Battle of Atlanta, and many streets reflect the names of some of the personalities of the battle, including McPherson, Blake, and Monument, and other pioneer families such as the Glens. Moreland Avenue was named for Major Asbury F. Moreland, who incorporated the first electric transportation system. Portions of I-20 cut through what was once a battleground. On the corner of Clay Street and Memorial Drive marks the spot of the start of the Battle of Atlanta.

Eight
EAST ATLANTA
EAST LAKE AND KIRKWOOD

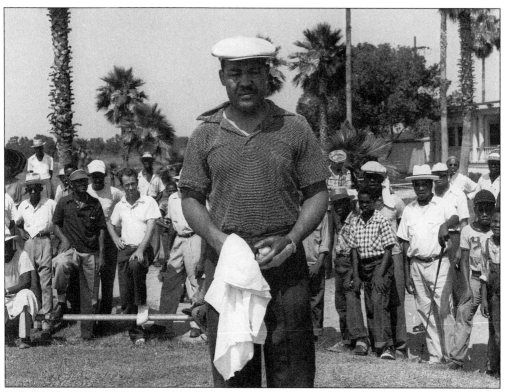

In 1904, the Atlanta Athletic Club bought property between Memorial Drive and Glenwood Avenue, and carved out what would become the East Lake Golf Course and Country club. Their goal was to build a resort complete with a golf course, tennis center, and a magnificent English Tudor clubhouse. During the early years of the club's development, the area surrounding East Lake became a popular summer retreat for families escaping the crowded city of Atlanta. African Americans were not allowed to play on the course but worked as caddies. The country club and accompanying residential development resulted in the town of East Lake, which was incorporated in August 1908. In 1928, the town became annexed to Atlanta. During the 1930s, middle-class families established permanent year-round homes and the neighborhood grew into a prosperous subdivision.

By the 1960s, a major racial shift occurred in the community. White families moved out as more African-American families moved in to occupy a public housing project, built on one of the two East Lake Country Clubs 18-hole golf courses. By the late 1980s and early 1990s, however, a number of white families began moving back to the East Lake community. Many of the public housing projects were demolished and replaced with moderate upscale dwellings.

The town of Kirkwood, named for one of DeKalb County's earliest settlers, James Hutchinson Kirkpatrick, was incorporated in 1899. Kirkpatrick arrived in DeKalb in 1827, an early Irish settler who amassed an estate of 1,000 acres. The family home was located near the intersection of Ridgecrest and Ponce de Leon Avenue. Between 1865 and 1900, Kirkwood was commonly known by Atlantans as "the home of John B. Gordon," a Civil War Confederate general who later became a United States senator and a governor of Georgia, and who also owned a 200-acre farm in the town.

Around 1922, the City of Kirkwood was annexed to Atlanta, making it part of the city limits and DeKalb County at the same time. Located adjacent to Kirkwood is the Edgewood community. African-American families were scattered throughout the area, including the Turner family. Charles Turner (seen here) chaired and organized the Edgewood Homecoming and family day for several years.

One of Kirkwood's most celebrated residents is Hosea Williams, civil rights activist and former DeKalb County commissioner. Born on January 5, 1926, in Attapulgus, Georgia, he was educated at Morris Brown College and received a B.S. degree in chemistry and his masters from Atlanta University. In 1960, he organized economic boycotts in Savannah and trained his volunteers in nonviolent tactics before becoming an aide to Martin Luther King Jr. and the Southern Christian Leadership Conference. In 1974, he became a member of the Georgia House of Representatives and served southeast Atlanta. On November 6, 1990, Williams was elected to the DeKalb County Commission with an 82 percent of the vote. Williams and his wife, Juanita, and their five children moved to the Kirkwood area in 1965, shortly after arriving in Atlanta. (Courtesy of William "Bud" Smith.)

Nine
LITHONIA

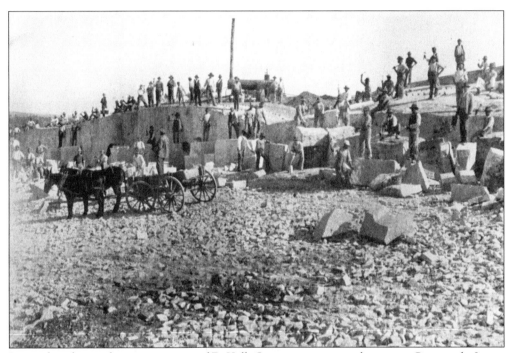

Located in the southeastern section of DeKalb County was an area known as Crossroads. It was later renamed Lithonia, taken from the Greek word "lithos," meaning "rock." The ground was extremely hard to till. A post office was established as early as 1832 and a tavern was operated for stagecoach stops on the Augusta-Nashville route. From Lithonia comes the only woman to have served from Georgia as a U.S. senator, Rebecca Latimer Felton, a white woman and daughter of Major Charles Latimer, who built the 1,000-acre Panola Plantation, which is now a series of subdivisions occupied by predominately African-American families. Lithonia was situated in the midst of one of the largest granite areas, leading to the development of large quarry companies that provided employment for African-American families. Shown above is the Pine Mountain No. 3 Lithonia Quarry workers. In 1856, the town of Lithonia was incorporated. Granite from Lithonia is used in buildings all over the country. Following the Civil War, African Americans migrated to the area. By the 1970s, there were over 2,200 black residents (48 percent of the population).

Today, Lithonia is a fast-growing area with sprawling subdivisions for middle- and upper-income African Americans.

In the 1960s, the Department of Transportation constructed and opened I-20, creating a major transportation hub for the area. (Courtesy of Patricia Wade Drozak, Georgia Department of Archives and History.)

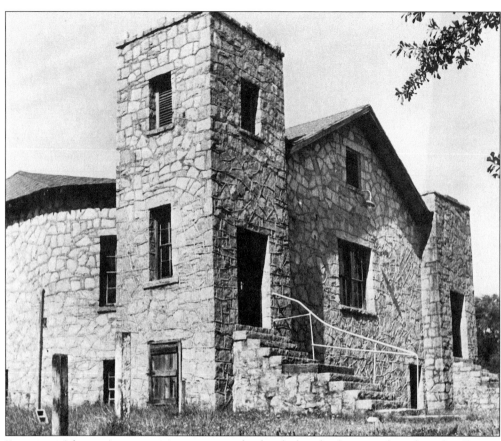

For many African-American communities, the local church also served as the schoolhouse. Fairfield Baptist Church was organized in 1885, under the guidance of the Reverend A.D. Freeman. It is said that the church was so named because it was situated in a field so flat that it was called "fair."

Fairfield was known as the "small church with a large heart." The church is now located on Redan Road, in Lithonia, Georgia. In 1884, African-American children in the Lithonia and Redan area were afforded an education at St. Paul A.M.E. Church (seen here) and Antioch Baptist Church. St. Paul began as a one-room building at the corner of Covington and Evans Mill Road around 1879. The school session lasted only three months. From 1884 until 1909, the two schools were affiliated; however, they later divided. In 1922, Rev. J.D. Dobbs, under the auspices of the Yellow River Association, began the Yellow River School. A fire destroyed the school in 1935 and special classes were held in the Mutual Aid Hall. Frankie Hardy, Corine Robinson, Mozelle Tyus, and Robinson Smith were teachers at the school. The principal was Mrs. Ethel Jackson, who, along with the community, raised funds for a new building. In 1938, the PTA, in conjunction with leaders of the community—Eugene Rainwater, Albert Usher, Grover Reynolds, Willie Bullard, Mr. and Mrs. T.J. Spratling, E.J. Bryant, Hillard Slocum, Mr. and Mrs. David Albert—acquired 6 acres of land and constructed the Bruce Street School at a cost of $18,000. (Courtesy of Mary C. Kelley, Georgia Department of Archives and History.)

The Bruce Street School in Lithonia was named for Amy Bruce and was a combination elementary and high school. The first principal of the school was Albert Brooks, followed by C.S. Greene in 1943, who resigned after one year to take a government job. In 1944, the school graduated its first high school class. The wooden building in the bottom image served as the Bruce Street School library in the late 1940s and 1950s. (Courtesy of Narvie Jordan Harris.)

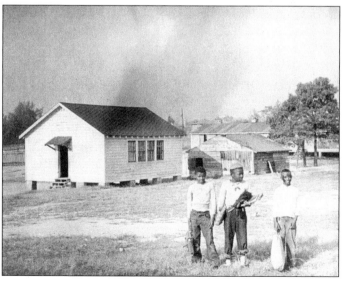

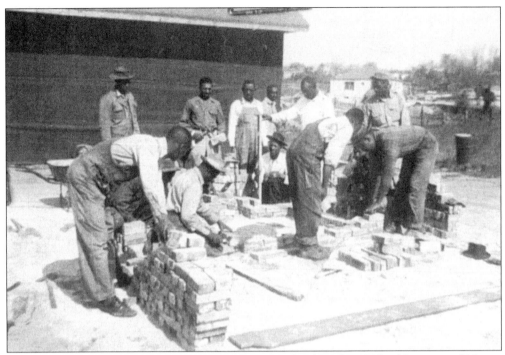

Pictured here is a bricklaying class at Bruce Street School in the 1940s. (Courtesy of Narvie Jordan Harris.)

Pictured here is the Bruce Street Chorus, *c.* 1948.

In the above photograph, local residents are seen participating in the groundbreaking for a new Bruce High School. Coy E. Flagg (right photograph) served as the principal for many years. Flagg joined the school in 1944. Other schools in the area included Rock Chapel, Stoneview, Lithonia High, and Salem Junior High School. (Courtesy of Narvie Jordan Harris.)

Pictured here is the newly constructed Bruce Street High School, c. 1965. (Reprinted from the Brucean Yearbook.)

The Bruce Street High School Eagles baseball team is pictured here c. 1965. (Reprinted from the Brucean Yearbook.)

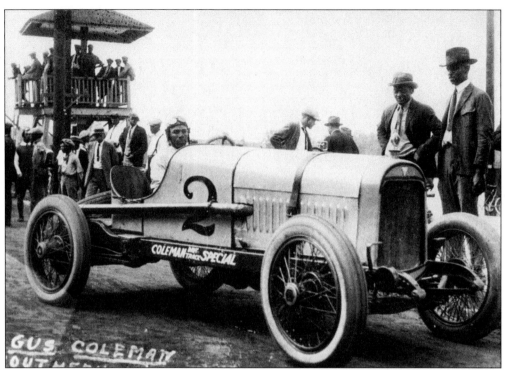

During the 1940s and 1950s, the Lithonia Speedway and Country Club was nestled in a secluded area off of Highway 12, on Rodgers Lake Road. It was a perfect venue for African-American stock car drivers, of which there were many, including George Muckles. An African-American dentist, Dr. Anderson initially operated the Anderson Lake Country Club until Otis Easley took over the club and renamed it. (Courtesy of the author.)

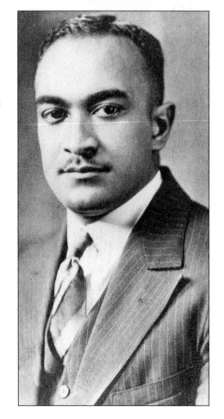

Dr. Benjamin F. Anderson was born in Gwinnett County on October 8, 1899. After graduating from Morris Brown College, he went on to study dentistry at Howard University School of Dentistry in Washington, D.C. In 1931, a year after graduating from Howard, he received his license to practice dentistry in the state of Georgia. He opened an office in the Odd Fellows Building, located on Auburn Avenue in Atlanta.

During the 1940s, Dr. Anderson and his wife, Agnes, also a graduate of Morris Brown, owned a tract of land on Rodgers Lake Road in Lithonia. The property on the land consisted of a large two-story house, a lake, and a racetrack. Dr. Anderson later sold the property, and it was converted into the popular Lithonia Speedway and Country Club. He died on October 19, 1950, at the Harris Memorial Hospital in Atlanta. (Courtesy of Lois Anderson Thomas.)

STOCK CAR RACES
100-LAPS-100
ALL COLORED DRIVERS
$1500.00 Prize Money LITHONIA SPEEDWAY

AT ANDERSON LAKE
18 Miles From Atlanta
On Highway 12

TODAY, SAT., MAY 29
Time Trials, 2 P.M.; Races 3:30 P. M.
Rain Date Saturday, June 5

GEORGE MUCKLES

MAIN ATTRACTION

George Muckles * Red Kines * Ben Muckles * James Lacey * Charlie Scott * Rail Head * Otis Blanton * Smith Hollis * James "Juckie" Lewis Chester Brown * Slim Blaylock * Arthur Avery (Decatur Express) all of Atlanta.

C. SCOTT

RICHARD KINES
OUT-OF-TOWN RACERS
The Williams Bros., Greer, S. C. * Booth Stocklan, Jacksonville, Fla. * Henry Rayford, New York City.
GREYHOUND BUSES LEAVE
1 P. M.—ROUND TRIP $1.50
Buses leave Hunter and Ashby Sts. at Noon; McDaniel and Rockwell Sts. 12:30 P. M., Fraser St. at Andy's Place, 12:45 P. M.; Auburn and Butler St. at 1 P. M.

ADVANCE TICKET SALE
Ace Cab Co., Auburn and Bell Street; Andy's Place, Fraser St.; Amos Drug Store, Hunter and Ashby Sts.; Sherman Service Station, 623 Simpson Street, N.W.; Auburn Tire and Battery Service Co. 300 Auburn Ave.

The speedway was host to many stock car races driven by African-American drivers, including George and Ben Muckles, Joe Daniels, Robert "Juckie" Lewis, Leon Wyatt, Walter Johnson, Charles Scott, Willie Armstrong, Robert Harvey, Willie Jackson, and Arthur "Decatur Express" Avery.

Each Fourth of July, the speedway would host its annual races and beauty contest featuring young women who would compete for the "Miss Stock Car" title. Admission to this annual event was $1.50. Prizes for the winners of the beauty contest often included all-expense-paid trips to Florida resorts. The race and contest were two of the most popular outdoor attractions for African Americans in DeKalb County. (Reprinted from the *Atlanta Daily World*.)

Adjacent to the speedway was the popular Lithonia Country Club, where dances were held and entertainment was provided by floorshows. James Brown, B.B. King, Little Richard, and many others traveling the "chittling circuit" performed at the country club. Admission to both events was $1.50. (Courtesy of the author.)

Lucious Sanders (left) is regarded as one of the pioneers of African-American activism in DeKalb County. He attended Georgia State College in Forsyth, Georgia, and taught school at Goodhope. After returning home from WW II in 1945 and finding that he could not register to vote, Sanders began an active civil rights campaign. He organized voter registration drives in Lithonia and pushed for African-American voting rights in Decatur. He was also a member of Union Baptist Church.

To promote civic awareness while fighting racial discrimination, Sanders founded the Lithonia Civic League. He also established the Anna Sanders Education Fund, a non-profit foundation named for his mother, which provided college scholarships and affordable loans to low-income students in Lithonia. Sanders's commitment and contributions to both Lithonia and DeKalb County are not only noteworthy, but are also truly remarkable. A gymnasium at Bruce Street/East DeKalb Center is named for him.

David Albert was born on a family-owned plantation in Redan, Georgia. The family also had its own cemetery on Giles Road. Albert was known to some as "militant" because he was one of the first civil rights activists in Lithonia and DeKalb County. He staged sit-ins in segregated restaurants in Lithonia and boycotted city buses. He stood on the corner of Main Street and Klondike Road and handed out pamphlets and literature. In the late 1950s, Albert was arrested for refusing to ride in the rear of the bus. He and his wife, Mattie, were longstanding members of Antioch Baptist Church. He urged fellow church members to take out lifetime memberships with the NAACP. He also organized secret NAACP membership drives, in order to avoid harassment from racist whites. His efforts as a warrior in the fight against racial injustice were eventually honored when the City of Lithonia changed the name of a street called Baptist Alley to Albert Way. The street is located near Lithonia High School.

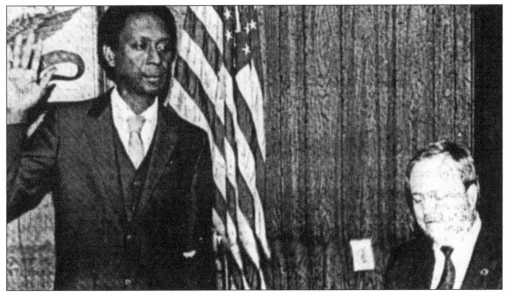

In 1984, Allison Venable, a foreman at Lithonia Lighting and former military man, was elected as the first African-American mayor of Lithonia by a two to one margin. He was also the first African American on the Lithonia City Council in 1973, defeating Elizabeth Mitchell with 223 votes to 137 in the election. Venable served for ten years on the Lithonia City Council, working with Ellis Woodall and Marcia Glenn, who would also become mayor. Venable also served as president of the Georgia Municipal Association for the fourth district. He and his wife resided in the Bruce Street community and had two sons. Woodall, a former teacher and employee of DeKalb Water and Sewer Department, is also a resident of the Bruce Street area. (Courtesy of Al Venable.)

In 1972, Maggie Wood became the first African-American councilwoman in Lithonia. A resident of Lithonia since 1935, Mrs. Woods raised all eight of her children in the city, including her daughter Marcia, who would become Lithonia's first African-American female mayor, and her son Jerome Woods, who was elected as police chief. Mrs. Woods recalls that when the children were small, they all drank from the same dipper and that there were three to four in a bed.

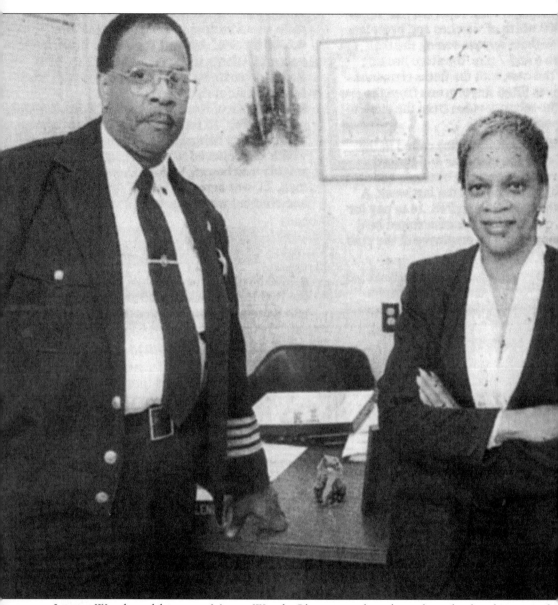

Jerome Woods and his sister Marcia Woods Glenn served as the police chief and mayor of Lithonia, respectively. Jerome was elected in 1981 and Marcia in 1995. They both attended Bruce Street School, and Marcia Woods Glenn went on to attend Clark College. After her mother retired from the city council, she assumed her mother's seat. She also works as a paralegal for the Environmental Protection Agency. (Courtesy of Dwight Ross/reprinted from the *Atlanta Journal/ Constitution*.)

Ten

LYNWOOD PARK

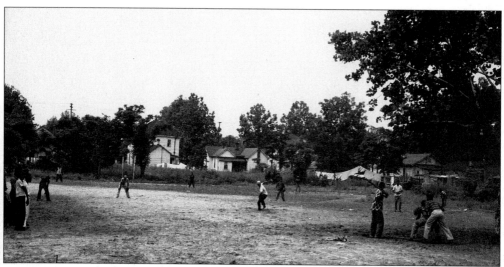

Located off of Peachtree Road in North Atlanta is a settlement known as Lynwood Park, considered to be DeKalb's oldest black community. Oglethorpe University is northwest of Lynwood, 2 miles south of Dunwoody. The first African-American family, the Bryants, moved into the subdivision known as "Cates Estate" in 1933 as a result of vacationing in Georgia. They returned to Pennsylvania, but eventually came back to the area to live in November 1943. Shortly afterwards, the community was renamed Lynwood Park (probably after realtor Mel Lynn). Many of the residents built their own houses, which were traditional modest white frame and brick. A year later in 1944, the Twelve Ladies Club was organized to help the community raise funds for schools, nurseries, and churches. The first chairwoman was Mrs. James Bennett.

By 1954, three additional African-American families resided there: the Hollands, Sims, and Clemmons. It was this kind of community involvement that aided in the installation of sewage systems, streetlights, telephone and electric services, a health center, a park, paved streets, better sanitation, and police services. In 1965, a survey of the community by Oglethorpe University showed a population of 1,703 residents, a number that would decrease dramatically over the years. Today, Lynwood Park shares its borders with the more upscale Brookhaven area and could have easily been wiped out through upscale expansion and the extensive building of $200,000 homes. As Buckhead has expanded, real estate developers have always eyed the property in Lynwood but have learned that this historical African-American community was and is not for sale. There was an attempt to buy out residences during the 1980s, even to the extent that blank sales contracts were often placed under the doors of residences offering $45,000 per parcel. As a result, the Lynwood Park Improvement Association was created. Between Mabry and Osborne Roads, one finds the heart of the community, although reports of increasing crime and drug use plagued the area during the eighties. With the aid of the DeKalb police, sweeping changes were made to alter the community's reputation and restore the pride that was once evident at Lynwood Park.

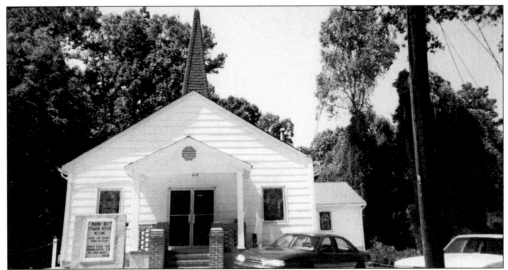

Businesses, churches, and housing dominated the area. Windsor Market, St. Peter's True Holiness Church, China Grove Baptist, which relocated to the Lynwood Park from Chamblee's Little Rock area, Little Zion Baptist Church, once pastored by Mrs. Georgia Clemmons, Mount Mary, and Lynwood Park Church of God can all be found in this historic DeKalb County district. In 1959, Lillie and Bishop Marshall Carter started a mission in the Church of God and Christ. The church eventually developed into the Lynwood Park United Church of God in Christ. By the 1990s, the church had over 600 members.

Today John Weiland Homes and the Capital City Club golf course have developed around this enclave, a small reminder of one of the many African-American communities undeterred by building and development.

The Lynwood Park High School basketball team, c. 1961, from left to right, are as follows: (front row) Grover Wilbon, James Brown, David Strickland, Peter Scott, Willie Anderson, Alfred Hood, and Albert White; (back row) Mr. W. Wade (coach), Hubert Neal, John Kirkpatrick, Samuel Colbert, James Lawrence, Charles Carter, Edward Langston, and Edward Brown. (Courtesy of Peter Scott.)

The Lynwood Park Elementary and High School (seen below) was located in the northern part of DeKalb County, near Chamblee. According to oral history, Mel Lynn also donated land to build the first school. Members of the community donated labor, supplies, and money and constructed the physical structure. Also included in a later consolidation were the Doraville and Lynwood Park Elementary Schools. The one-story brick building had nine classrooms, an office, and storage room. There were nine teachers including the principal Rev. E. Newberry. By 1949, total enrollment for the school was 317, with 249 in the elementary school department and 69 in the high school. Principals included L.A. Robinson and Harvey B. Coleman (pictured above). The school began publishing a yearbook in 1962. (Courtesy of Peter Scott.)

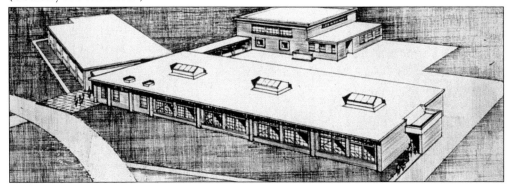

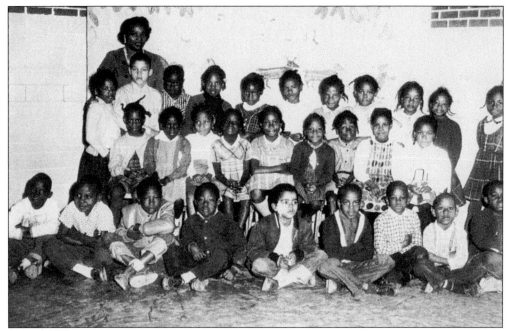

Pictured above is Mrs. Jackson's second-grade class at the Lynwood Elementary School, c. 1963. After the school closed, it was refurbished and opened as a community and recreation center, a common trend for many of the former black schools in DeKalb County. (Courtesy of Peter Scott.)

Peter and Frankie Scott raised their 15 children in the Lynwood community. In the late 1950s and 1960s, Frankie had eight children enrolled at the Lynwood Park High and Elementary School. One of her sons, Peter Scott, became a journalist for the *Atlanta Journal and Constitution*, and her daughter, Mozelle, became an administrative assistant at Morehouse College.

Eleven
MILLER GROVE, REDAN, AND SCOTTDALE

Nestled off Miller Grove Road in Lithonia is a community bearing the same name, which was named for "old Man" Miller, a prosperous landowner. The African Americans residing in this community were a tight-knit group. As early as 1919, a school was established called the Miller Grove School, located on Panola Road. After the original school burned down, the Miller Grove Baptist Church served as a school site, as did the Cedar Grove Methodist Church on River Road for almost seven years. In addition to Mrs. Rainwater, Mrs. Clarice Jordan also served as principal of the school. Later, students attended Bruce Street School and Lithonia High School, which was not integrated until 1969. The community also maintained its own cemetery and burial grounds with the help of the Independent Masonic Lodge of Miller Grove. Portions of the cemetery are still located near Marbut and Welborn Road, though numerous homes were built over areas of the burial ground for residents of the Miller Grove community. In the 1970s, an effort was made to build a new junior high school on Miller Road. After successful petitioning, Mrs. Ida Bell Moody and the former Miller Grove residents rallied to have the school named for the community, rather than a particular person.

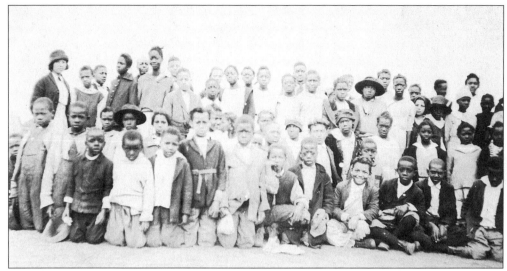

Redan was located near Lithonia, Georgia, bordering the Stone Mountain parkway. Students in the area attended the Redan school, a one-teacher school serving at one time by Mrs. Emmie Smith. The name "Redan" was believed to have been coined from the name of two original settlers, N.M. Reid and Mrs. Annie Alford. Many African-American families, including the Clark and Ragsdale families, lived in the rural area of Redan.

Located in central north DeKalb County, and named for George Washington Scott, the Decatur fertilizer baron and founder of Agnes Scott College, is the town of Scottdale. Mr. Almond of Conyers, Georgia, gave it the name. In the 1900s, the Scottdale Mill (owned by the Scott family) provided jobs for a large portion of African-American families. In 1982, the Scottdale Mill closed, leaving many residents jobless and uncertain of their financial future.

Although the Scottdale Mill employed most of the African-American residents of Scottdale, there were others who worked as rock, stone, and brick masons, auto mechanics, and cement finishers. Scottdale's most notable African-American citizens were George Howell and Julius Henderson. Dr. Conrad Allgood, a white physician, served all races in his home. The Heard family owned a cemetery and was one of the first African-Americans families to settle in Scottdale, along with Nancy Kendall, her family, and the legendary Tobie Grant. By the late twenties, many other families had settled into the Scottdale community, including the Norman family. M.C. Norman, who would later go on to Morris Brown College, received a Ph.D. and retired as the principal of one of the Atlanta public schools. He was one of the founding members of New Birth Missionary Baptist Church and a former member of Travelers Rest.

The second church established in Scottdale was Old Chapel Baptist Church in 1897 under the leadership of Reverend Kilgore. The churches provided a spiritual and educational foundation for the Scottdale community. Other churches that would be built later included New Chapel (1920) and Norman Grove (1923), established by Rev. S.E. Charleston and Deacon Joe Hill. Bishop W.F. Lucas established Lucas Temple True Church of God in Christ in 1954. Bishop George Hope founded the Church of All Nations in 1965. Other churches located in the Scottdale community included Calvary Grove Baptist Church, St. James Baptist Church, Old Mt. Pleasant (renamed Moss Temple), Early Church of God Ephesus, Bethlehem Baptist Church (renamed First Canaan Baptist Church), Cherry Street Church of God in Christ, and Little Jerusalem and Travelers Rest Baptist Church.

In 1939, 15 people under the leadership of Rev. Hezekiah Smith organized a church and named it Travelers Rest Baptist Church. Mrs. Fannie Bell, one of the mothers of the church, had suggested the name. Four ministers served the church following Reverend Smith: Rev. Theodore R. Smith, Rev. Eugene Bryant, Rev. Chester L. Carter, and Rev. Kenneth Samuel, who became the minister in 1982. In 1983, Reverend Samuel and members of the Deacon Board looked for a suitable new location, and in January 1984, they acquired the former Life and Praise Tabernacle at 2778 Snapfinger Road. On May 20, 1984, around 150 people moved into the new church home and approved the new name, New Birth Missionary Baptist Church. Reverend Samuel served until 1987, and then Rev. Eddie Long was appointed pastor. Today, New Birth has grown to over 18,000 members.

By Berdie Ricks

The induction ceremonies for the C.N. Cornell Chapter of the National Honor Society and the J.Y. Moreland Chapter of the National Jr. Honor Society were held in the gymnasium of B. T. Washington High last Wednesday morning.

The J.Y. Moreland Chapter is a new chapter that has been added to the Honor Society, named in honor of the present principal, Mr. J.Y. Moreland. This chapter is composed of sophmores and freshmen.

The purpose of the honor society is to recognize outstanding scholastic abilities and achievements of students, as well as to help induce other students to make better grades. members of the National Honor Society are chosen by vir-

Continued On Page 6

Animal Life, Space, Electricity, Atmosphere and Weather, Solar System, and the Universe.

Exhibits attest to the preparation being given pupils to cope with society today. Basic concepts vital to the understanding of space missiles, rockets, etc. were made and explained by the pupils.

Electric motors fashioned of cork and nails, transformers radiometers which encompass the prin-

Continued On Page 6

Bruce Street will be a gymnasium, also, designed by Tri-State Architects

Education

Continued On Page 6

$225,000 BREAKTHROUGH - Mrs. Gussie Brown, president of Hamilton High School's P. T. A., and Mrs. Lillie Bryant, past president, share the shovel at a ground breaking ceremony for a new addition to the school. Shown in the rear are Mr. Clarence Glass, architect, Mr. William Hatton, Principal, Mr. Jim Cherry, Superintendent DeKalb County Schools, and two seniors, Misses Marietta Robinson and Carolyn Williams. The entire construction and renovations planned for Hamilton will cost $225,800.

NO. 1 IN STATE - Gilbert Anderson, Carver High School senior and an honor student, proudly displays his eight inch "L" corner which won his school first place in the Georgia Youth Industrial Education Association State Contest in the brick - laying division. Anderson will graduate this June and plans to attend either Tuskegee, Hampton, or Savannah State next fall.

Pictured above in the left photograph are Mrs. Gussie Brown, a Scottdale resident and president of Hamilton High School's PTA, and Mrs. Lille Bryant, past president, who share in the groundbreaking ceremony for a new addition to the school in 1962. Others pictured, from left to right, are as follows: Clarence Glass, architect; William Hatton, principal; Jim Cherry, superintendent of DeKalb County Schools; and two seniors, Marietta Robinson and Carolyn Williams.

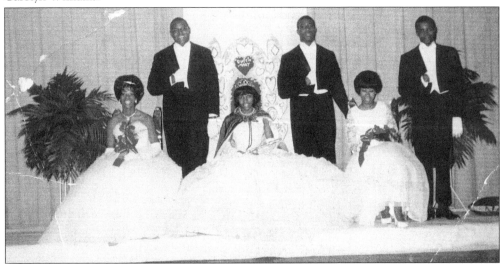

The Hamilton High School Coronation of 1966 represented students from various communities in DeKalb County. From left to right are as follows: Iris Graham (LaVista Road), first attendant; Mary Joyce Lundy (Scottdale), Miss Hamilton High; and Mary Joyce Bailey (Tucker), second attendant. (Courtesy of Lula Bailey.)

Tobie Grant, known to most Scottdale residents as "Aunt Tobie," was a seer, healer, advisor, and businesswoman. She owned an insurance company, cemetery, and several tracts of land. Her real notoriety, however, came from her work as a fortuneteller, or as she preferred, "sense-giver."

From the 1920s through the 1950s, Grant had up to 50 visitors a day calling on her for spiritual and financial advice. She did not use crystal balls, tea leaves, incense, or any other paraphernalia normally associated with fortunetelling. She simply relied on prayer as her guide. And in so doing, aided many people in finding missing jewelry and important papers.

According to oral history, Grant helped the DeKalb County Police Department locate the bodies of two murder victims. She is also said to have predicted the invention of the atom bomb 15 years prior to its creation. Tobie Grant was also a philanthropist. She gave a large tract of land to the county in order to provide a children's park.

The tall obelisk marks the final resting-place of Nancy Kendall, former slave and mother of Tobie Grant. It is not known when she died or when the marker was erected at Washington Park Cemetery. Her daughter Tobie Grant died in 1968 and is buried in the Washington Memorial Cemetery in Scottdale. The Roberts Marble Company, the marble for which was provided by the Georgia Marble Company, built Nancy Kendall's marker. Today there is a library, park, recreation center, and housing project named in her honor. Tobie Grant's accomplishments are a real tribute to the African-American heritage of DeKalb County.

Pictured here is the entrance to the Scottdale Cemetery on Jordan Road. The street was renamed in 1985 from Scottdale Road to Jordan Road for a resident of the street and one of the community's most outstanding citizens, Cleveland R. Jordan.

The Washington Park Cemetery (now known as the Washington Memorial Park) contained a section called Pauper's Field. This section was designated for the poor of the area. The cemetery was adjacent to the Scottdale Cemetery. It was reported in the newspaper that thousands of persons attended the spectacular opening of the cemetery and the unveiling of the monument to Aunt Nancy Kendall. The program included speakers, and a barbecue was served to the sounds of brass bands. (Reprinted from the *Atlanta Daily World*.)

Twelve
STONE MOUNTAIN

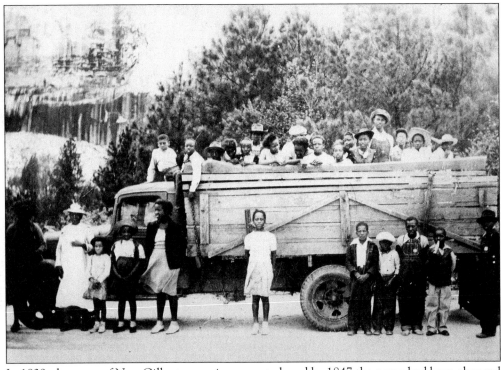

In 1839, the town of New Gilbrater was incorporated, and by 1847 the name had been changed to Stone Mountain. Three years later the population of the area included 10,466 inhabitants, of which 2,004 were slaves and only 2 were free persons of color. The 1860 Slave Inhabitants record listed at least 290 slaves in the town of Stone Mountain and no record of free African Americans.

By 1880, Stone Mountain had a flourmill, sawmill, cotton gin, cabinet shops, and gristmill, all operated by steam. The first quarry opened in 1858. The major goods produced and shipped mostly at the hand of African-American labor were cotton, granite, and whiskey. On the southeastern edge of Stone Mountain, African Americans developed a new community. They named it Shermantown in honor of Union General William Tecumseh Sherman, who, according to legend, spent a night in the vicinity of Lithonia. It was separated from the main commercial districts by large undeveloped blocks owned by the Venables, as well as a pond near Poole Street, which was used for baptisms by Bethsaida Baptist Church. (Courtesy of Atlanta History Center.)

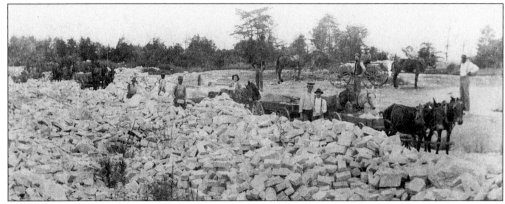

By 1890, Stone Mountain was the second largest urban center in the county. A campaign to move the county seat from Decatur to Stone Mountain failed. Stone Mountain remained a prosperous and industrious village and major tourist destination. In 1915, a streetcar line linked Stone Mountain with Decatur, which allowed town residents easy access to Decatur and Atlanta. It was also the year that the newly resurrected Knights of Klu Klux Klan used the top of the mountain as a ceremonial/meeting place. This, along with property owned by James Venable, the former imperial wizard of the National Knights, created an identity of deep racial hostility for the small village. The Venables had dual roles as vigilante justice seekers and quarry owners. The Venable Brothers, as well as Stone Mountain Granite, owned a large quarry, later the Southern Granite Company. It employed African Americans from Shermantown and was the major draw for persons moving to the area.

Shermantown's boundaries were Venable Street, south to Lucille Street, west of Second Street, and east of Main Street. There were small one-story buildings, shotgun houses, and L-shaped cottages, a lodge hall, and school on Fourth Street. Shermantown also had a baseball team, which played at a field located near the current Leila Mason Park.

Until 1867, numerous African Americans attended the First Baptist Church, later renamed Rock Mountain Baptist Church, which was formed in 1839. The Bethsaida Baptist Church was located in Shermantown and was organized in 1868 by Reverends R.H. Burson and F.M. Simmons. The St. Paul A.M.E Church was also located in Shermantown on Fourth Street and was believed to have been established in the 1870s. Another cemetery was located near Ebenezer Church in Shermantown.

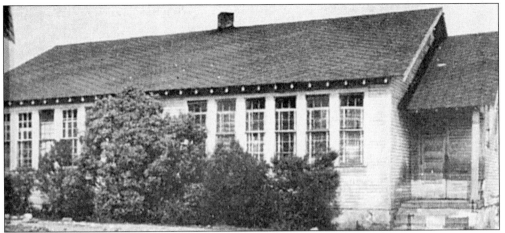

The Stone Mountain Colored Elementary School Building was constructed in the 1920s with funds from the Rosenwalds, a philanthropic family and organization. There was a red schoolhouse at the corner of Stillhouse and Fourth Street. The building was a four-room structure, composed of four teachers and located at the foot of the mountain on East Main Road. Enrollment in 1949 was 152 students. Several of the former teachers were Mrs. Lula Harper and Mrs. Frances Maddox. The school had safety patrolmen, scouts, a sewing circle, and a mechanics club. As with most schools, community involvement was important. The community helped to secure a stove for the kitchen and venetian blinds for every window in the school. (Courtesy of Narvie Jordan Harris.)

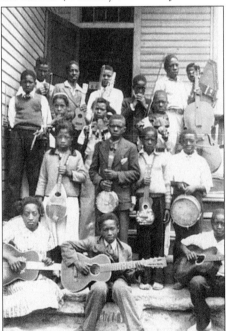

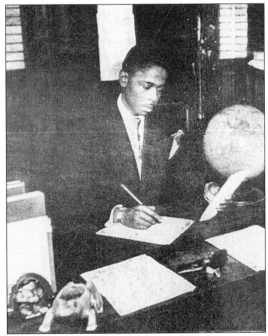

Left: Stone Mountain school band members pose outside of the school, *c.* 1930s.
Right: In 1949, Mr. Earl F. Jackson III was the principal of the combined elementary and high school. Later, a school was built and named in 1956 for Victoria Simmons. It replaced a school that was located on Venable Street in honor of an African-American woman who resided on Ashby Street.

115

The Ebenezer Missionary Baptist Church, located on Stillhouse Road in the Shermantown area of Stone Mountain, was erected in 1917 under the leadership of Rev. James Tanner on land owned by P. McCurdy. The church structure was rebuilt in 1954. (Courtesy of the author.)

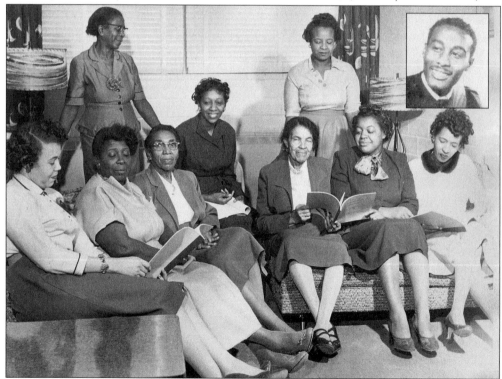

Pictured here, from left to right, are teachers of the Victoria Simmons School: (seated) E. Mallory, Frances Maddox, Lula Harper, Narvie Harris, Ora Woods, Z. Stafford, and Ruby McClendon; (standing) Fannie Dobbs and Jondelle Johnson. Edward Bouie Sr. (inset) also taught and served as the principal. Jondelle Johnson would become a journalist and columnist for the *Atlanta Voice* and executive director of the Atlanta branch of the NAACP, where she served for 17 years until her death in April 1998.

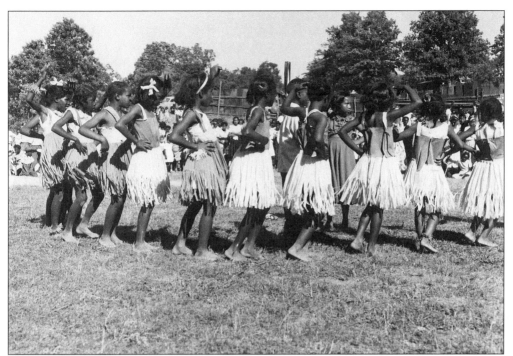

There were many May Day activities at Victoria Simmons Elementary School, *c.* 1950s. (Courtesy of Narvie Jordan Harris.)

Located on Third Street in the Shermantown community is the St. Paul A.M.E. Church. The current building's construction began on September 20, 1959, under the pastorate of Rev. Lonnie Young and the presiding prelate Bishop William R. Wilkes, who served as the chairman of the board for Morris Brown College. (Courtesy of Skip Mason Archives.)

Now occupied by antique shops and stores, a portion of Main Street leading to Stone Mountain in 1917 consisted of African Americans who owned property, including F.W. Simmons, Laura Wright, C.J. Britt, Ham Hudgins, Mrs. J.M. Street, and Doctors D.F. Smith and W.T. McCurdy. The McCurdys were large landowners in Shermantown.

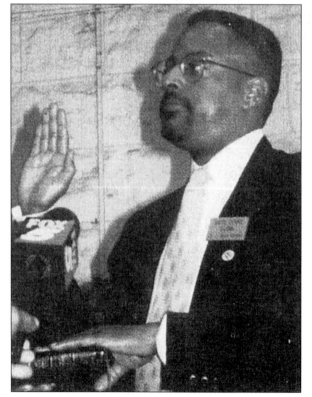

On January 6, 1998, 46-year-old Chuck Burris was sworn in as Stone Mountain's first African-American mayor. A former city councilman for six years, Burris lives in a house once occupied by Klu Klux Klan Imperial Wizard James Venable. He ended up in Stone Mountain after a realtor told him it was a great place to live and joined Bethsaida Baptist Church. Burris pledged as mayor to increase community-oriented police patrol, zero tolerance for drugs, and support for recreation and art. While on the city council, the council voted to rename a portion of Old Memorial Drive after James Benjamin Rivers, a 40-plus-year employee of the City of Stone Mountain who began as a garbage collector and worked his way up to chief of police.

Thirteen

TUCKER

The city of Tucker was named for Henry Holcomb Tucker, former president of Mercer University and chancellor of the University of Georgia. An advocate of education, Tucker was also president of the association that became the forerunner of the Georgia Association of Education.

In the early 1900s, an African-American community known as Pearidge was intentionally created in an area of Tucker, Georgia. The African-American residents provided a labor pool for the whites in surrounding neighborhoods. According to longtime African-American residents of DeKalb County, this systematic placement of African-American domestics near their employers was a common practice. The men were brickmasons and rockpilers and the wives of these men worked primarily as maids. Evidence of this geographic pattern of racial settlement in rural communities is also supported by the fact that small enclaves of African-American communities are often found in close proximity to affluent white neighborhoods.

Lucious Peters and his wife, Amanda (seen in these two photographs), were the first African-American homeowners in Tucker, Georgia. Peters was born on July 12, 1890, in Morgan County, Georgia, to Mr. and Mrs. Henry Peters. After marrying Amanda, the Peters family (including their three daughters) purchased land in 1935 and constructed a home in an area that later became named for them—the Peters community. Their home was built on a former sweet potato patch. When they arrived, the area consisted of only woods, gullies, and red mud. The Peters were members of the Little Miller Grove Baptist Church, which they joined in the early 1930s. Lucious Peters was chairman of the Deacon Board and a member of the Little Grove Masonic Lodge #571. Amanda Peters was actively involved in the uplifting of her community. The Georgia League of Negro Women Voters honored her for her work.

In the years following, other African-American families moved into the Peters community. It was not long before the residents realized the need for a civic organization. Subsequently, in 1946, the Tucker Action Club was founded. The club was responsible for bringing streetlights, water, a sewer system, neighborhood clean-ups, voter registration, and a two-room school to the Peters community. Later the Peters Park was constructed.

In 1981, through the efforts and persuasion of the Peters community and the original Tucker Community Action Club, a park was built by DeKalb County officials. During a time when few African Americans owned homes or land, the residents of the Peters community in Tucker were vanguards in making things better for the African-American community. The original members of the Tucker Community Action Club, from left to right, are as follows: (seated) Roosevelt Fowler, Nanny Lou Fowler, Edie Mae William, Annie Bailey, Amanda Peters, and Bessie Peters; (standing) Rev. Billy Peters, Elvie Bailey, Rev. Ermond Ramey, Clifford Moreland, Jeff Booker, and William McKinley Peters. (Courtesy of Jeff Barker.)

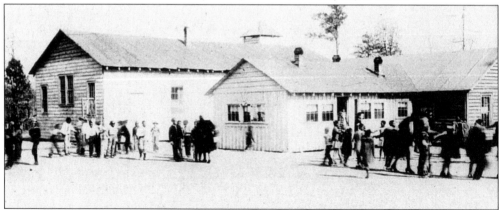

This is a view of the Tucker Elementary School, (c. 1940) located 3 miles below Clarkston and 2 miles from Stone Mountain. The school was a one-teacher school with an average of 55 students and had numerous clubs including the Community Club, 4-H, Health and Citizenship Clubs, Boy Scouts, and the Red Cross. One of several principals included Fannie Dobbs. (Courtesy of Narvie Jordan Harris.)

The Tucker community and surrounding areas were entertained with the music of the Tucker Independent Community Singers, a popular group on the church circuit. Shown, from left to right, are: Sidney Ball, Victoria Peters, Lillian McIntyre, Ada McClintock, Corene Kelly, and Annie Bailey, *c.* 1940s. (Courtesy of Annie Bailey.)

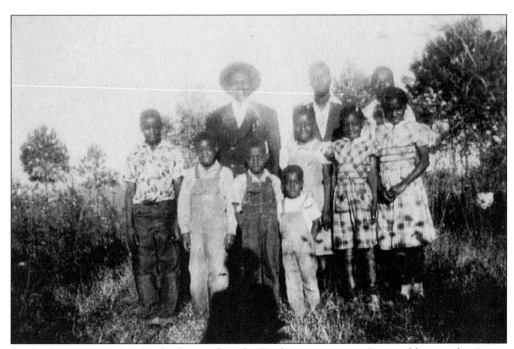

By the 1940s, many families had moved to the Tucker community. Pictured here is the Aaron Clark family, who resided on Clark Drive. (Courtesy of Annie Bailey.)

Pictured here is the Elvie Bailey family on Easter Sunday. From left to right, they are as follows: Mary Joyce, Shirley, Elvie, Lula, and Greg. Elvie Bailey was born in Lilburn. He and his wife, who was born in Dacula, moved to Tucker in 1956. (Courtesy of Annie Bailey.)

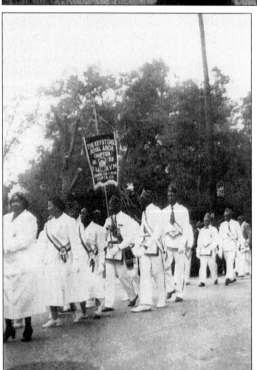

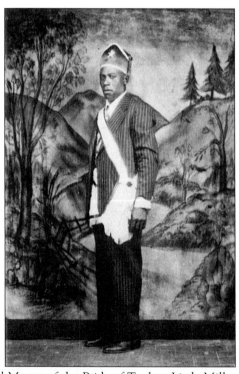

Elvie Baily (right photograph) was the Worshipful Master of the Pride of Tucker, Little Miller Grove Lodge and the deputy director of the DeKalb County Smooth Ashlar Grand Lodge. He was given full fraternal rites upon his death in 1992. (Courtesy of Annie Bailey.)

Fourteen
SOUTH DEKALB

The southern most portion of DeKalb County is the South DeKalb area, where many of the early residents settled along the South River, which, according to the *Atlanta Journal and Constitution* writer Laura Raines, became a part of the of the county's growing farm economy. Around 1843, Major Charles Lattimer built the 1,000-acre Panola Plantation. Lattimer's daughter, Rebecca Lattimer Fulton, became the first woman to serve as a U.S. senator. Spread throughout South DeKalb were numerous African-American families living in areas known as County Line, Flat Shoals, Panthersville, Cedar Grove, Arabia Mountain, and Ellenwood. Areas such as Lithonia and Turner Hill and streets including Evans Mill, Browns Mill, Snapfinger, River Road, and Panola are also located in South DeKalb. South DeKalb contained most of the DeKalb's undeveloped land, which has resulted in the development of hundreds of subdivisions.

The Hopewell School and Church (seen here) was located on Bouldercrest Road near the Cedar Grove and Conley area. Mrs. Fannie Eberhart was the principal in 1944.

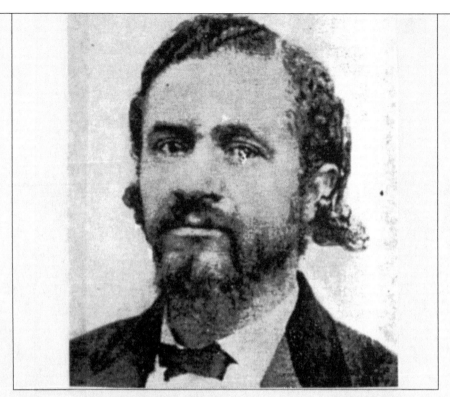

DR. RODERICK BADGER

Dr. Roderick D. Badger was the first African-American dentist in Atlanta, Georgia. Born in south DeKalb County in 1830, he worked as an itinerant rural dentist, earning a living by traveling from county to county. He lived in the Panthersville district of DeKalb County until 1856. During that same year, he moved to Atlanta to practice dentistry. According to oral history, a family named Johnson residing near Blue Creek encountered a panther, hence the name Panthersville.

Several white Atlanta citizens presented a petition to the city council, protesting the fact that a "Negro dentist" was allowed to practice in the city. Despite the opposition, Dr. Badger continued to practice—even working on Sundays to pay for his instruments.

During the Civil War, Dr. Badger served as an aide to a Confederate Army colonel. He later went on to serve on the board of trustees for Clark University, then located in the South Atlanta area. In addition, he became a large landowner in Atlanta, which included his office on Peachtree Street and his home on east Harris Street.

Dr. Roderick Badger died on December 27, 1890. He was a model of excellence in his field and a symbol of pride for the African-American community. (Reprinted from the *Negro History Bulletin*.)

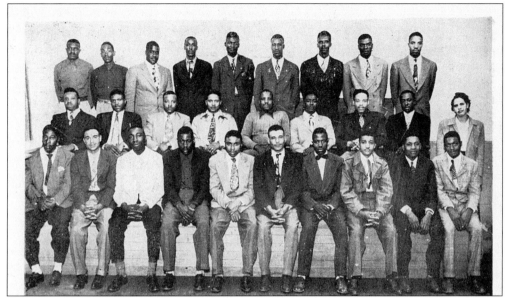

The County Line School was located near the southern county border near Ellenwood. The frame structure consisted of an office, first-aid room, four classrooms, and an auditorium all heated by a hot-air furnace. The school grew from a one-teacher school in 1946 with an enrollment of 233, to three teachers in 1949. Former teachers were Fannie Eberhart, E.M. Morgan, L.E. Mosley, and V.M. Scott, who taught sixth and seventh grade and also served as principal. The County Line School also operated a veterans' class, with Mrs. L.E. Mosley as instructor. Class officers were Willie Booker, president; Willis Turner, vice president; Rufus Evans, secretary; and Amos Womack, treasurer.

In 1972, a former dairy farm and pasture was cleared for the development of the 700,000-square-foot South DeKalb Mall. Flanked by such streets as Whites Mill Road and Rainbow Drive, today it is only one of a few malls targeted specifically for an African-American clientele. Within a 5-mile radius of the mall are 210,000 people, 80 percent of who are African Americans. According to *Georgia Trend* magazine, the average household income is $45,568, and 25 percent have college degrees. The mall was acquired in 1997 from the Rouse Company for $20 million. Across from the mall, small remnants remain of the old Mathis Dairy. A portion of the cow pasture was redeveloped into the Renaissance Lake Subdivision.

VOTE DeKALB'S FUTURE

Elect

JAMES E. DEAN

REPRESENTATIVE

DeKALB HOUSE DISTRICT #76

SEPTEMBER 11 DEMOCRATIC PRIMARY

Educated to Serve — Trained to Lead

JAMES E. DEAN

JOIN THE DEAN TEAM!

The DeKalb County chapter of the NAACP was established in 1956. John Henry Shanks was elected the first president of the DeKalb NAACP and through strong leadership laid the foundation for an active chapter. He died in November 1986, leaving a wife, Jessie, and four daughters.

From its inception, this civil rights organization has fought the forces of racism in DeKalb County. Among some of its former leaders are John Evans, a former member of the DeKalb County Board of Commissioners; Phil McGregor, of the DeKalb County Board of Education; and former State Senator Eugene Walker. The DeKalb County branch has been a continuing source of support for the African-American community. It has focused much of its efforts on the problems of the African-American youth—teen pregnancy, drugs, and crime—through workshops, conferences, programs, and other activities. When it comes to the DeKalb County branch of the NAACP, one can always find them on the front line, fighting social and racial injustices.

In 1983, John Evans, former president of the DeKalb chapter of the NAACP, was elected the first African-American commissioner of DeKalb County. As commissioner, one of his initial tasks was to open a district office in the African-American community on Candler Road. This was part of his effort to put constituents "in closer touch" with their representative. Commissioner Evans also organized weekly visits around the South DeKalb district in a motorized van, dubbed his "mobile office." Each Saturday, he would visit different locations, soliciting input and questions from his constituency. Evans's innovative departure from traditional commissioner involvement helped to bridge the gap between the African-American community and DeKalb County's public officials.

Pictured here is the campaign card of James E. Dean, who was elected in 1968 to the Georgia State Legislature as a representative of DeKalb County. His areas included Edgewood, Kirkwood, Parkview, East Lake, and College Heights.

ACKNOWLEDGMENTS

It has always been my goal to find wonderful images and information not previously known, and to make them accessible to all who desire to see, know, and learn. I am eternally grateful to all the people who have helped make this book possible. Dexter Weldon, a former researcher for Digging It Up, was the principal researcher on this project in 1996 and did an outstanding job of collecting data and images during the earlier stages of this project. He even attended one of the annual Decatur Reunions and created a list of former residents that is unmatched. Michelle Carnes, former administrative assistant, edited with precision a previous version of the text for the DCVB. It has been my pleasure to pull the pieces of previous research and write the text for this book, to revisit some of the history-makers of DeKalb County, including the legendary Narvie Jordan Harris, whose wit and wisdom is unmatched. Her archives (located in her garage and surrounding her white Cadillac) provide a collection so rich that this book could not have been done without her and her photographic images that she has amassed as supervisor of the Jeanes School in DeKalb County. A special thanks goes to the DeKalb Historical Society (Carolyn Khadian and Sue Ellen Myers). A visit to Sylvia Ann Kemp Clark, whose great-grandfather, Henry Oliver, was a pioneer settler in Beacon, produced a beautiful suitcase filled with wonderful images and documents from her family. A gifted artist, she generously shared her material and oral history with me and led me to the home of Mollie Clark Mills, who was also so generous with her memories and photos. A lunch date with Cynthia Jones at the very end of this project revealed her family's ties to Ellenwood, Georgia, and led to a quick change in content and layout to include this important information. Special thanks to her family, including her father, grandmother, and aunt, for their loan of photographs, and to Greg Bailey for his contribution on Tucker, Georgia.

As with all of my projects, I am grateful for the support of my family, church, and friends who always encourage me just when I need it. Other persons that I am grateful to for their assistance, including sharing of information and loan of photographs, include Susie Allen, Lula Bailey, Fannie Bailey, Greg Bailey, Lilly Bailey, Edward Bouie, Jacquelyne Welch Burke (my former English teacher at D.M. Therrell High School, whose family lived in Beacon), James Bussey (who took us around Decatur and pointed out where buildings, families, and "things" used to be), Otis Carr, Josephine McClain Chandler, Judge Clarence Cooper, Annie Davenport, Calvin Espy, Mattie Espy, Mayor Marcia Glenn, Eva Green, Harper Hill, Rena McDaniel Hill, Genelle Hollis, Cynthia B. Houston (for graciously allowing us to participate in the Decatur Reunion), Ellen Lester (Hamilton High School Yearbooks), Alberta W. McFarland, Mollie Mills, Wanda Manigold, Dr. Johnnie Myers, Mary Lundy Robinson, M.C. and Bobbie Norman, Yvonne, Norman, Olitha Reed, Deacon Rogers, Dorothy Williams Scott, Sadie Sims, Frances Terrell, Lois Anderson Thomas, James and Connie Stokes, Rosemary Strong, Sara Turks, Mayor Al Venable (for entrusting us with your photo album), Bill Walker (Washington Memorial Cemetery), Mel Walker (for sharing information on Mt. Zion A.M.E. Church), Pauline Morgan White (for sharing your Trinity Yearbooks), Vanessa White, Mayor Elizabeth Wilson, and Maggie Woods. To "Sweet" Rene, Casper L. Jordan, who edited this, along with my previous works for Arcadia, thank you. Finally, I could not ask for a better support group than my DeKalb County posse, Mozelle Powell, Larry and Barbara Epps, Maurice and Gina Jenkins, Patrick and Debbie Stephens, Dr. Carl Walton, Wilma Toney, Tanyeeta Goodjoines, Horace Derricote, Ernest White, Reverend Viola, and Tony Macklin.

Skip Mason
September 1998

BIBLIOGRAPHY

Clark, Caroline McKinney. *Vanishing DeKalb: A Pictorial History*. Decatur: DeKalb Historical Society, 1985.

Galambos, Eva. *What's in a Name: Place and Streets in the Atlanta Area*. Columbus: Quill Publications, 1996.

Inscoe, John C. *Georgia in Black and White: Exploration in the Race Relations of a Southern State 1865–1950*. Athens: University of Georgia Press, 1994.

Price, Vivian. *The History of DeKalb County Georgia 1822–1900*. Fernandina Beach: Wolfe Publishing Company, 1997.

Rampersad, Arnold. *Jackie Robinson: A Biography*. New York: Alfred A. Knopf, 1997.

NEWSPAPERS
Atlanta Business Chronicle
Atlanta Daily World
Atlanta Journal and Constitution/City Life/DeKalb Intown Extra
Atlanta Sentinel, July 1978
Champion Newspaper
Decatur Community Review
DeKalb News/Sun
Decatur DeKalb News Era
Georgia Trend
Inter-Scholastic Journal, May 18, 1962
North Side News

Reverend Herman "Skip" Mason, a native and resident of Atlanta, DeKalb County, is a graduate of Morris Brown College and Clark Atlanta University. A former adjunct professor of history at Morehouse College and founder/president of Digging It Up, Inc., he is the author of several publications, including *Going Against the Wind: A Pictorial History of African-Americans in Atlanta*; *Hidden Treasures: Black Photographers in Atlanta*; *Alpha in Atlanta: A Legacy Remembered*; *As Alpha South Goes, So Goes Alpha: The Southern Region*; *The Talented Tenth: Biographies of the Seven Jewels of Alpha Phi Alpha Fraternity*; *African-American Life in Jacksonville*; *Black Atlanta in the Roaring Twenties*; and *African-American Entertainment in Atlanta*. He also pastors the St. James C.M.E. Church in Washington, Georgia.